THE MASTER GUIDE

for *Wildlife*
Photographers

Bill Silliker, Jr.

AMHERST MEDIA, INC. ■ BUFFALO, NY

Copyright © 2004 by Bill Silliker, Jr.
All rights reserved.
All photography by the author unless otherwise noted.

Published by:
Amherst Media, Inc.
P.O. Box 586
Buffalo, N.Y. 14226
Fax: 716-874-4508
www.AmherstMedia.com

Publisher: Craig Alesse
Senior Editor/Production Manager: Michelle Perkins
Assistant Editor: Barbara A. Lynch-Johnt

ISBN: 1-58428-114-6
Library of Congress Card Catalog Number: 2003103025

Printed in Korea.
10 9 8 7 6 5 4 3 2 1

Dedication

This book is dedicated to Leonard Lee Rue III.

Several years ago, I was excited to accompany him in the Maine woods. His look at my book *Just Loons,* with author Alan Hutchinson, told him that I could find loons for him to video. When a nonphotographer friend asked why that was such a thrill, I explained that Rue was the venerable wildlife photograph columnist with *Outdoor Photographer* magazine.

"If it was rock and roll, it'd be like doing a gig with Chuck Berry," I said.

"Oh, so he's the guy who invented wildlife photography?"

Not quite—but close.

Frustration at my inability to photograph wild animals sixteen years ago led me to his book *How I Photograph Wildlife and Nature* (W. W. Norton 1984). I read it three times! That book made me into a real camera hunter and a fan of his column. But I never dreamed I'd shoot with him and become one of his many friends.

I led him close to nesting loons that he could shoot without interfering. A month later, an editor at *Outdoor Life* magazine called: "We're doing a two-page spread on Canadian moose. Lennie Rue says you've got the photographs we need." Lennie taught me another lesson: A true professional is never too famous to say thanks for the help.

Speaking of which, if this book helps you half as much as his did me, then we'll be sharing a fine tradition.

Thanks again, Lennie. Catch yours in the good light.

table of contents

Introduction5

1. The Nature of Wildlife
 Photography8

PART 1. THE KEYS TO SUCCESS
2. Know Your Species12
3. Know Yourself21
4. Know Your Equipment . . .25
 The Camera25
 The Lens26
 Frame Advance
 and Autofocus29
 Tripod30
5. Know Your Film34

PART 2. METERING FOR PERFECT
EXPOSURES—EVERY TIME
6. Meters Matter40
7. Natural Gray Cards47
8. Species Adjustments50
9. Metering After the Fact . . .54

PART 3. A FOCUS ON FOCUS
10. Auto Or Manual Focus . .57
11. An Eye For an Eye61
12. Bracket the Focus Point .66

PART 4. HOW TO
GET CLOSE ENOUGH
13. Know When to Be Where to
 Shoot What71
 Food is a Key73
 Sex is a Key74
14. Approach Techniques76
 Open Approach79
 Mobile Blind Approach80
 Animal Impersonation81
15. Blind Moments84
 Semipermanent Blinds85
 Portable Blinds85
 Really Portable Blinds87
16. Camera Platforms88
 Motor Vehicles88
 Canoes90
 Other Watercraft91
 Aircraft92

PART 5. PICTURE THIS
17. Three Types of Wildlife
 Photographs93
 Wildlife Portraits93
 Behavior Images95
 Scenic Wildlife Images96
18. Wildlife Compositions . .100
 Compositional Elements . . .100

The Rule of Thirds104
Horizontal or Vertical105
19. It's All in Your
 Background107
 Select the Background107
 Raise or Lower
 the Camera108
 Move the Camera
 Position108
 Wait for the Animal
 to Move108
 Direct the Animal108
20. Lighting: Au Naturel? . .112
 Front Lighting114
 Side Lighting114
 Back Lighting114
 Light Reflected
 from Below115
21. What's Wrong
 with This Picture?116
 Evaluating Chromes116
 Evaluating Digital Images . .116
 Evaluating Prints117
22. Be Prepared—Always . . .118
 Ready or Not118
 Weather or Not119

Index122

introduction

The Master Guide for Wildlife Photographers offers a unique look at the rapidly growing sport of wildlife photography. While a professional wildlife photographer who travels throughout North America in search of wild animal images wrote it, the average amateur can apply the techniques learned from it right in their own backyard. And they won't need top of the line equipment to get started.

Experienced amateurs will find it most helpful. And even a professional might pick up a few tricks to make the difference with some animal, some day, some place.

While anyone can get a few lucky shots of wildlife now and then with any decent camera, to regularly bring them back alive you need:

• the "right" equipment
• some skill at using it
• the knowledge of a field naturalist.

Most people make the mistake of paying attention to only the first two

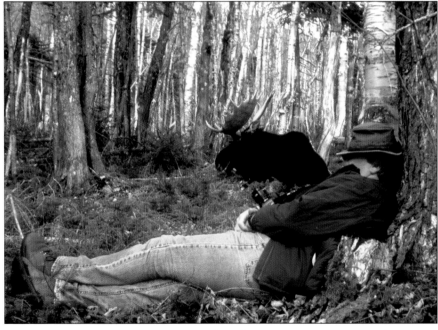

items. But the consistent pursuit of quality images of wild creatures requires that you know something about them first. If there is a magic secret to success at wildlife photography, it's this: know as much as possible about the animal that you want to photograph.

By example, because of a long fascination with moose, I've learned a great deal about how to work with them. That's resulted in a large file of

"The Mooseman"—a nickname I earned after many years of photographing moose. (Photo courtesy of Alan Hutchinson)

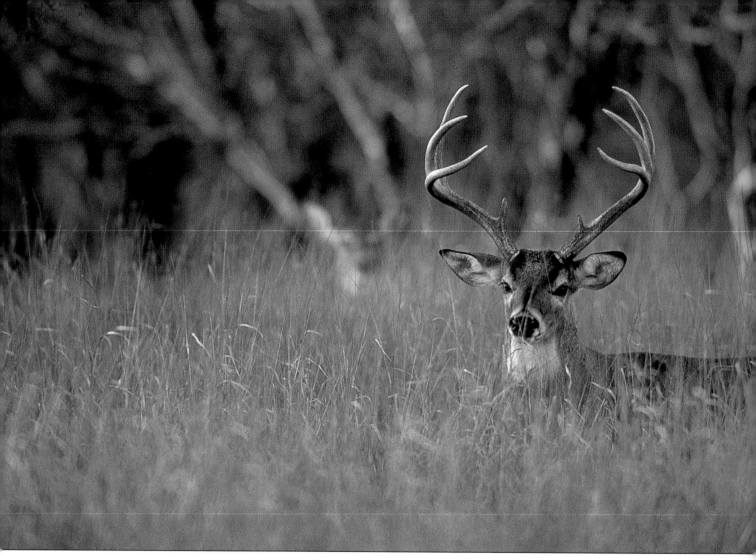

all moose subspecies in North America, four books on moose, and a nickname: The Mooseman.

But I first learned how to photograph wild animals by working with white-tailed deer. Whitetails provide a most challenging target for wildlife photography. And they live throughout North America.

A wide variety of bird species does too. So you don't have to live near any moose to be able to practice and polish the techniques in this book. You can use them to get closer to wildlife for consistently effective results anywhere in North America.

What about Africa? I've never been there. But you could apply the lessons learned here to photography

ABOVE—White-tailed deer present a real challenge for wildlife photographers. They live throughout most of North America. FACING PAGE—Everyone has wild birds available to work with. The trick is in getting close enough for an effective photograph.

of any wild animal anywhere in the world.

And as for Africa, I've never felt enough of a desire to go there. There's simply so much to cover in North America and so many places to shoot here.

Besides—Africa has no moose.

1. the nature of wildlife photography

• How do you put it all together to make a great wildlife photograph?
• How do you select the right subject, season, time, place, background, film, equipment, and technique to make a trophy image?

Can birds count? Do white-tailed deer see in color? Do moose have good hearing?

Those might seem strange questions for a book on wildlife photography. But this book is different from other books about nature photography. While it covers exposure, composition, and other of the usual subjects, every topic is approached with a primary goal: to teach you how to consistently get good photographs of animals in the wild.

Wildlife photography involves a lot of work and does not always meet with success. But getting it right takes more than some luck.

A trophy image requires that you get close enough to an animal with a great background in good light that you properly set an exposure for with a fast enough shutter speed while you frame for artful compositions

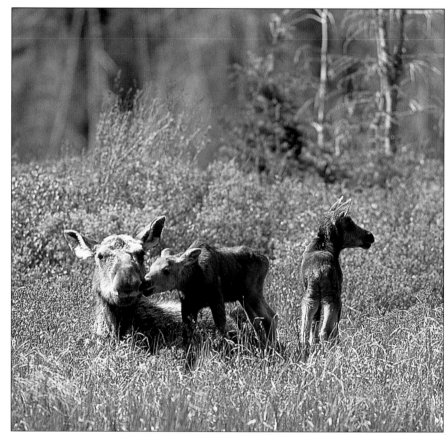

Working with this moose family required hiding from a very cautious mother, having the wind advantage, and a lot of patience.

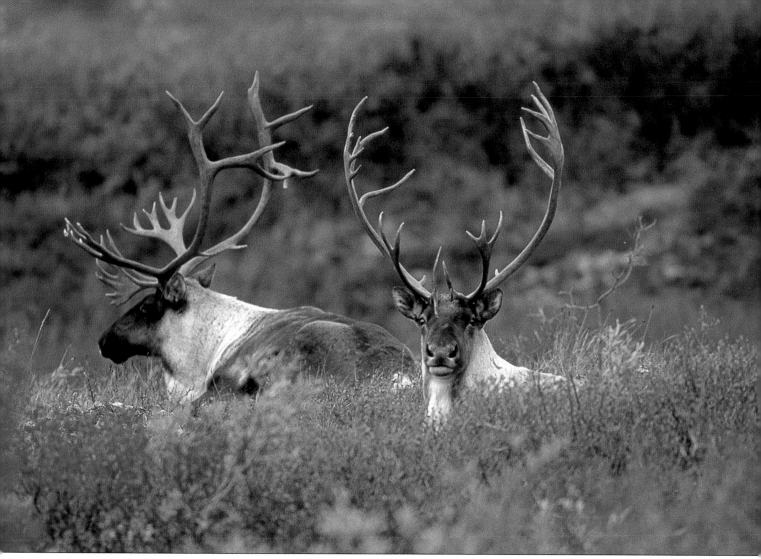

Where the "camera hunters" of old got only one photograph from a close encounter with wildlife like these two caribou, the well equipped and ready photographer of today can often shoot a roll or more.

and focus dead on its eyes so that they're sharp while keeping the camera and lens steady so that you don't blur the photograph.

To accomplish that, you need to know not only sound photographic techniques but also how to apply them quickly and smoothly to the making of images of wild animals. To consistently do that, you really do need to know something about wildlife.

And so the real wildlife photographer must learn how to "hunt" with a camera, because he or she works with truly wild animals most of the time. Simply stated, real wildlife photography is the sport that combines the techniques of the photographer with those of the successful hunter. Unlike the hunter, the wildlife photographer pursues the image of a wild animal for a trophy. The quarry remains alive.

And it's a lot more difficult.

George Shiras, the man who many credit as "the father of wildlife photography," first took up the camera in 1889 after spending many years in the woods as an accomplished game hunter. But Shiras had to devise ways to photograph wild animals, either by using remote cameras triggered by trip wires or with a "flashlight"— a flash powder device fired after sneaking up on an unsuspecting animal by canoe at night. He wrote and photographed the first article on wildlife photography ever published in *National Geographic* magazine in 1906.

Arthur Radclyffe Dugmore, another early practitioner of the sport, described in his 1913 book, *Wild Life and the Camera* (J. P. Lippincott Co.), how he worked for six years to get his first decent photograph of a herd of caribou in Newfoundland. Six years.

Dugmore's passion for the moment when it all came together and his feeling that he had finally succeeded at a most difficult task—recording the beauty of wild animals that he feared faced extinction—come across clearly in his words of long ago.

Do you really have to sit in a blind and wait for six years to get an animal's photograph? Not today. In fact, many photographers photograph some "tame" animals, even captive ones. If professional wildlife photographers had to hide from every animal they want to photograph, they probably wouldn't collect enough images in a lifetime to stay in business.

Why bother to pursue wild animals if zoo specimens or captive wildlife models are readily available? Because most such animals are so used to humans that they have lost a certain spark, and that often shows in your photograph. An air of alertness, or at the least of cautious trust, always seems evident in images of wild animals.

And while the photography of animals in the wild is more difficult, it's also more exciting. A special thrill is derived from a photo session with one of the wild, free running animals that we share the planet with. And so the real wildlife photographer looks for wild subjects that will tolerate an encounter with a human or finds ways to hide from those that will not.

Which brings us back to the question that opened this chapter: Can birds count? Crows can. But most other bird species do not. Or at least they don't notice when two people get into a blind and only one walks away. And so they readily come back and pose for the knowledgeable wildlife photographer.

Consistent success at wildlife photography also requires total familiarity with one's gear. Simply knowing how to use your equipment, which buttons to push, and what the meter says are all good places to start. But that's not enough to meet the challenges of photographing most wildlife. You must train yourself to use

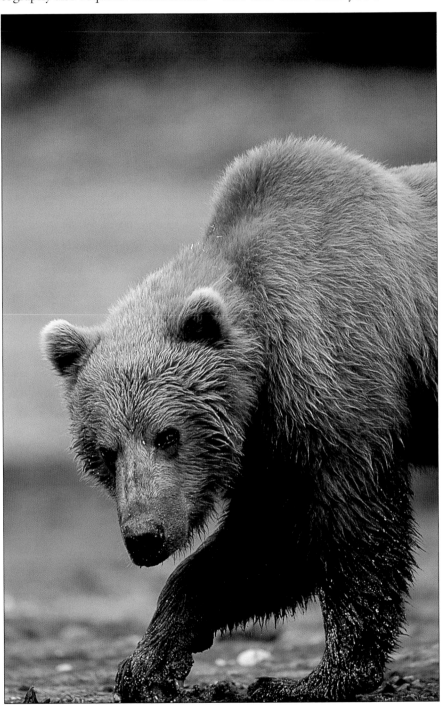

Wild animals have an air of alertness—sometimes more—as displayed by this Alaskan brown bear.

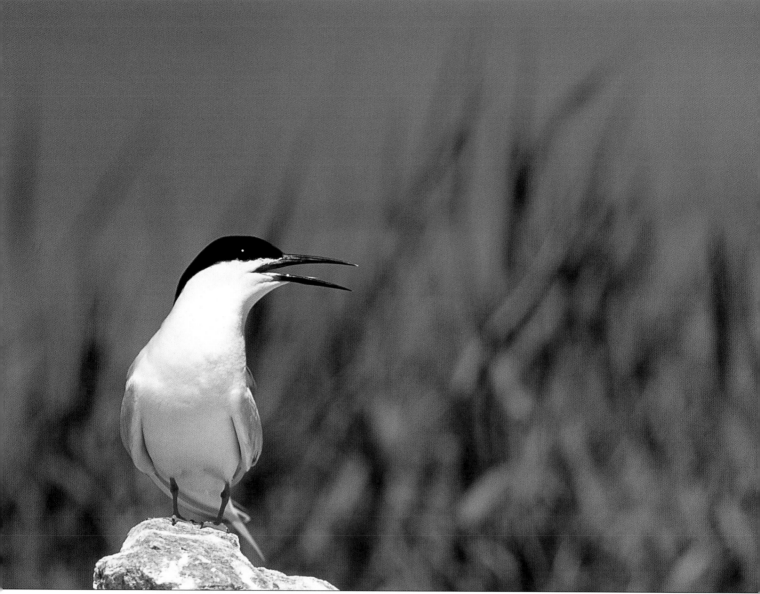

your equipment as a reflex action. And you must be ready to react quickly. The best way to do that is to get out there and to shoot some pictures using the techniques that you learn in this book.

What kind of camera do you need? Most photographers shoot with a 35mm system with interchangeable lenses. While you can spend many thousands of dollars for equipment, you can also buy a good system to get into wildlife photography as a hobby for under a thousand dollars. And we're talking about a system that includes a 500mm telephoto lens.

If your interest is in wildlife photography as a profession, it pays to get the best equipment and to use professional film or a high resolution digital camera from the outset. A major difference between professionals and amateurs is the amount of time spent in the field. It only makes sense to get the best product from such efforts if you can.

Whatever your interest in wildlife photography, once you discover that there's nothing quite like the thrill of capturing a wild animal on film and knowing that it's still out there somewhere, watch out. You're likely to get hooked on it too.

Knowing that terns can't count helped to get this photograph. This endangered roseate tern came back shortly after the researcher led the photographer to the blind and left.

2. *know your species*

- How do you find wild subjects?
- How do you know when to be where, and for what?

The keys to consistent success at wildlife photography are to:

- know your species
- know your equipment
- know yourself
- know your film.

While each plays a part in the making of every great wildlife image, none is more important than knowing something about the species that you want to photograph.

The Mooseman's first rule of wildlife photography says that the photographer who wants to get trophy images of wild animals has to learn how to get close enough. That knowledge is as valuable as figuring out how to load film in a camera. Success with "workable" wild animals requires that the photographer treat them with respect to earn their confidence. Success with nonwork-

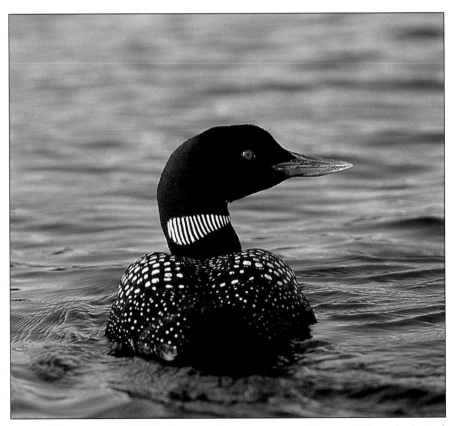

ABOVE—The serious wildlife photographer wants more than a quick grab shot of the east end of an animal headed west. FACING PAGE—A vehicle served well enough as a blind that this bald eagle landed nearby for an action portrait with a 500mm lens.

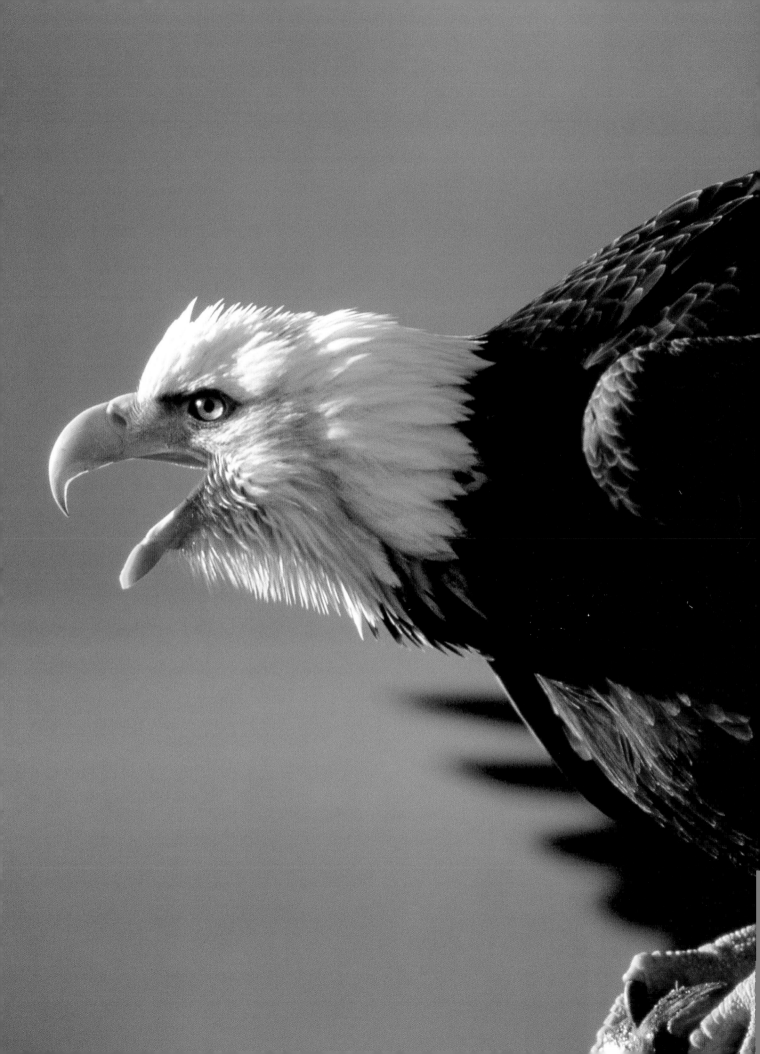

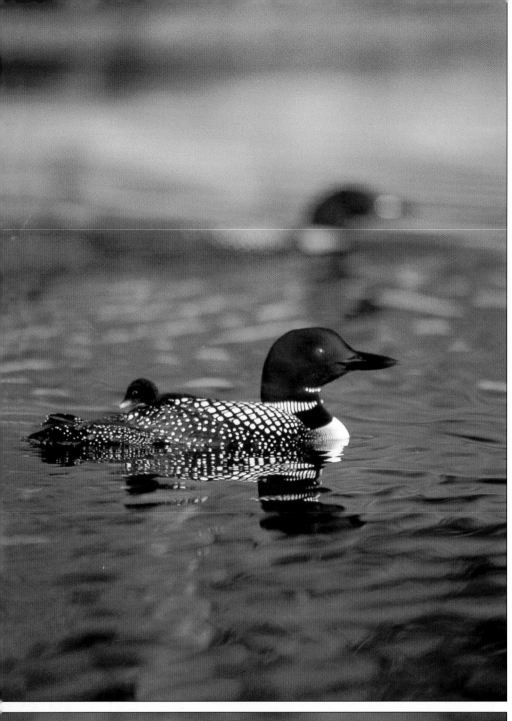

able ones requires that you know how to get close without their knowing. To do either well you must know something about the characteristics of a given species.

The Mooseman's second rule of wildlife photography says that the pursuit of wildlife with a camera often seems to involve waiting in the wrong place. While discovering ways to improve your ability to sit still might help, it really makes more sense to figure out what are the best possible places to do your waiting. To get the really good stuff usually requires more than a grab shot from a chance meeting in the woods. You want a "workable" animal, one that you can shoot plenty of film on. The key to finding such animals lies in learning their basic biology.

The wildlife photographer who knows something about wildlife can also target a species at a time. You can still shoot anything that steps or flies into camera range, but your efforts generally pay off better if you plan for a single species before you head out the door. Doing that enables you to invest your time where those particular critters most

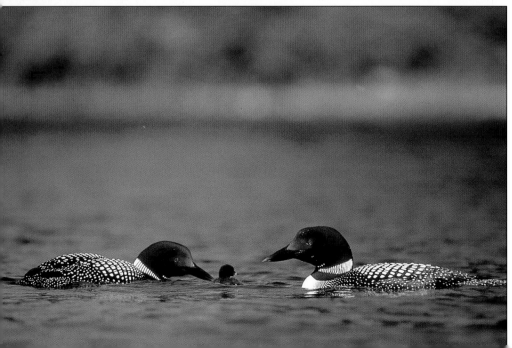

TOP—This common loon family trusted me in the presence of their newly hatched chick because I didn't push them. Patiently waiting when working with wild subjects can produce some rare opportunities. BOTTOM—After showing off their new chick, the loons fed it right in front of the canoe. Note that all three birds lined up in range of the narrow depth of field of the telephoto lens.

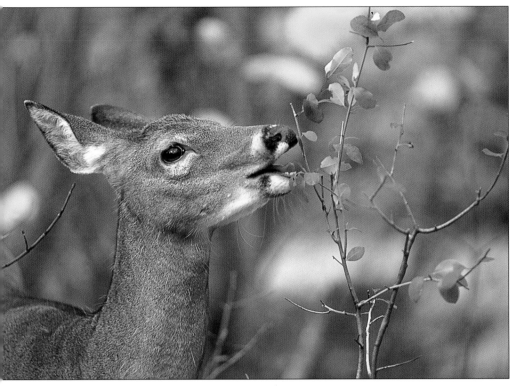

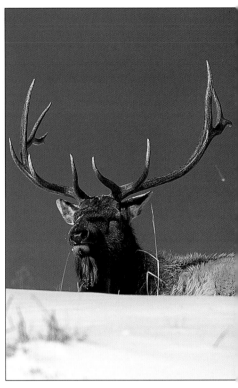

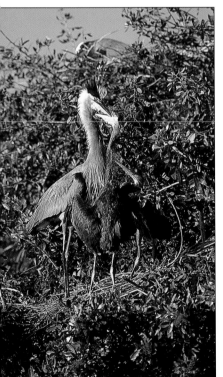

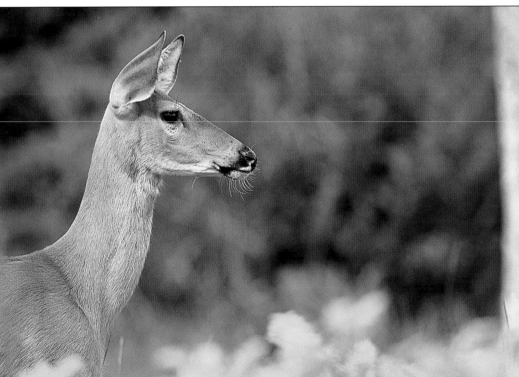

TOP LEFT—White-tailed deer browse a variety of vegetation and twig ends. Capturing an animal in such behaviors makes an interesting photograph. TOP RIGHT—Where does an elk sleep? This bull chose the top of a hillside. Working at the camera position permitted including a clean background of blue sky. BOTTOM LEFT—Photographing birds in Florida is easy. To get something different, capture behavior in good light with an attractive background. BOTTOM RIGHT—White-tailed deer have an acute sense of hearing. Pictures that demonstrate an animal's capabilities make interesting photographs.

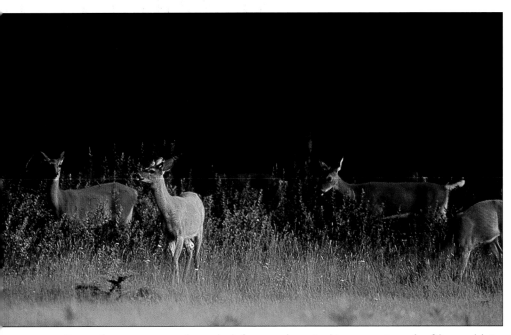

Deer often come out along dark forest edges. In this case, since the film couldn't record the dark woods that the human eye could see, it makes a more intriguing photograph. Learning what your film of choice can and can't do is important.

likely hang out during daylight hours.

What do you need to know about a wildlife species in order to get better opportunities to photograph it? While the answer to that question varies with the species, some essential things to know about any species include:

• What does it eat? When? Where?
• What habitat does it prefer?
• Where does it sleep? When?
• Is it afraid of people?
• Is it dangerous to be around? At how close a proximity?
• Is it only nocturnal? Diurnal? Or does it come out both in daylight and at night?
• Does it show itself on windy days?
• How well does it see? Hear? Smell?
• When does it mate?
• When does it give birth?

• Does it move seasonally? If so, where does it go? When does it return?

The white-tailed deer offers a good example. These animals have survived for centuries because they have great capabilities to detect a threat with senses that make them one of the most wary of quarries for the camera. And yet the photographer who knows how to work with those senses can do quite well.

How much do you know about whitetails? Most folks who've never tried to photograph wary whitetails think that if they hide, they can get close enough for good pictures. But anyone with a bit of experience with these deer soon learns that keeping one's scent from deer is as important as hiding from them. And so enterprising whitetail photographers learn how to keep the wind advantage.

But is a keen sense of smell the greatest of the whitetail's defenses? An oft-quoted Native American saying goes something like this: "A leaf fell in the forest. The eagle sees it, the bear smells it, and the deer hears it." Anyone trying to get close to a whitetail also needs to consider its acute sense of hearing, which, depending on the situation, is often the first and foremost concern in trying to outwit these deer.

The photographer also needs to catch a deer in enough light to adequately record its image on film. But deer don't often pose in strong light.

When and where do you most often see whitetails? Isn't it usually along the edges of fields at dawn or dusk, or in the shade of the woods that they use as cover, if not in the woods themselves?

Knowing that they have incredibly good hearing, an extremely keen sense of smell and reasonably good vision, especially for things in motion, can help you to figure out ways to get close enough to catch them on film, even in marginal light.

How? First understand that whitetails are very curious animals. They also know their home range—the specific areas in which they spend most of their lives—as well as you know your living room. If something new appears in that range, it sticks out to them like the proverbial sore thumb.

But if they can't smell it or make it out clearly, they will often approach it to determine exactly what it is. As they come closer, they'll often drop their head, then raise it quickly,

either to see if the intruder moved, or perhaps to get a different angle of view on it.

They respond with as much curiosity to foreign sounds. Would you believe that a whitetail's inquisitiveness rises when it hears the click of a camera shutter? If you're concealed well enough to hide your human form, even a really wild deer might actually come closer after it hears that first click! But if it smells human scent, sees any motion, or hears the crack of a stick it will bail out on you before you ever get to push the shutter.

You should also know that deer make many body language signals to each other. They display signs of aggression, alarm, fear, and other "feelings" that you need to recognize if you're trying to get closer for a photo opportunity.

- A twitching tail indicates normalcy as deer feed. Feeding deer often look up to check for danger, then flick their tail before returning to feeding.
- A raised and flared tail says a deer is alarmed. Other deer seeing this signal will be on the alert as well. If you move or make any noise, they will probably explode into motion. Don't even blink! If the

deer giving the alarm sign goes back to normal behavior, wait until any others in sight relax as well.

- A foot stomp also signals alarm. And it leaves an unseen message: a hard stomping deer leaves an alarm scent from glands in its

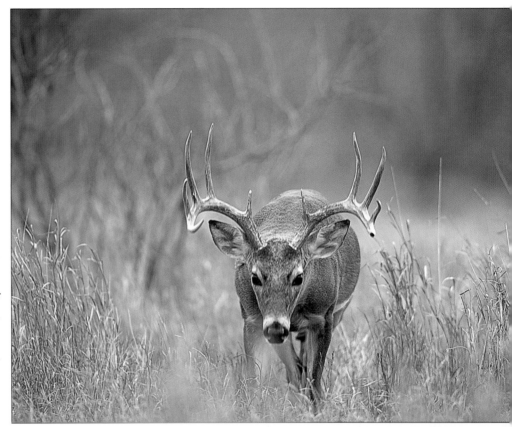

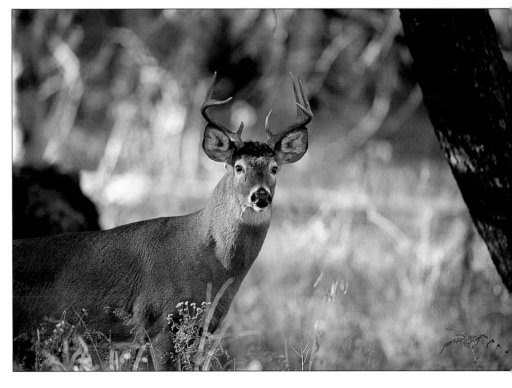

TOP—This whitetail has dropped its head to get a different angle of view on the intruder. Note the threatening body language. BOTTOM—This wary whitetail came closer at the click of the shutter because it couldn't see or smell the photographer.

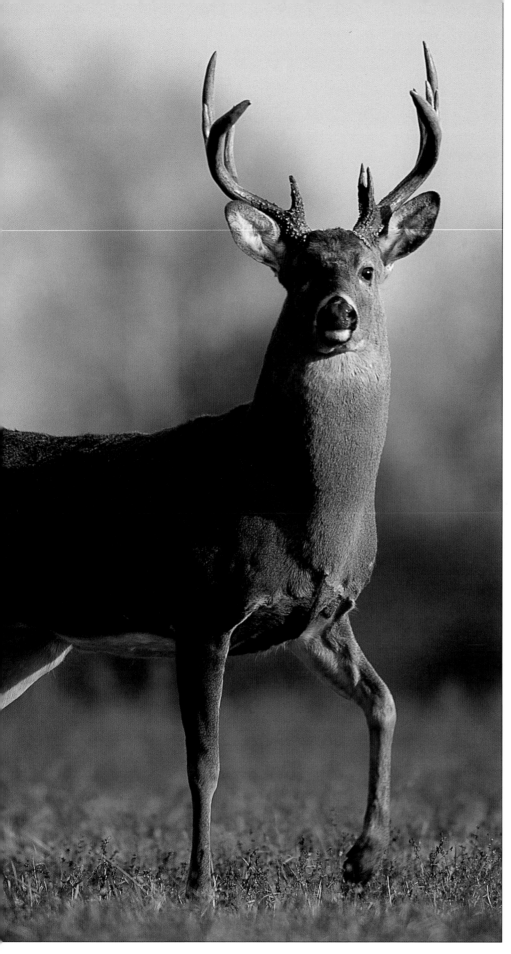

hooves. Waiting for another deer to pose at that site is probably a waste of time.

Deer also make a variety of vocalizations to each other. Spend some time with whitetails and you'll hear these calls and more:

- the grunt—a low-pitched, guttural "hello" sound made by bucks
- the blat—a similar, higher-pitched "hello" sound made by does
- the bleat—a high-pitched call made by fawns to their mothers
- the snort—an explosive sound of alarm or surprise
- the scream/snort—a definite danger alert that makes deer run.

Every individual animal of any given species will also react based upon its experience with humans. You should know that you become part of that animal's experience as soon as you attempt to get closer to watch it. The cumulative life experience of any given whitetail deer with close encounters of the human kind may well determine its response to its next meeting with Homo sapiens.

So, how can you learn about any species?

Collecting and reading the many good books on a variety of individual wildlife species is a good place to start. The most successful professional wildlife photographers have book-

A buck stomps the ground and leaves a warning scent. The photographer who understands whitetail ways will look elsewhere for photographs.

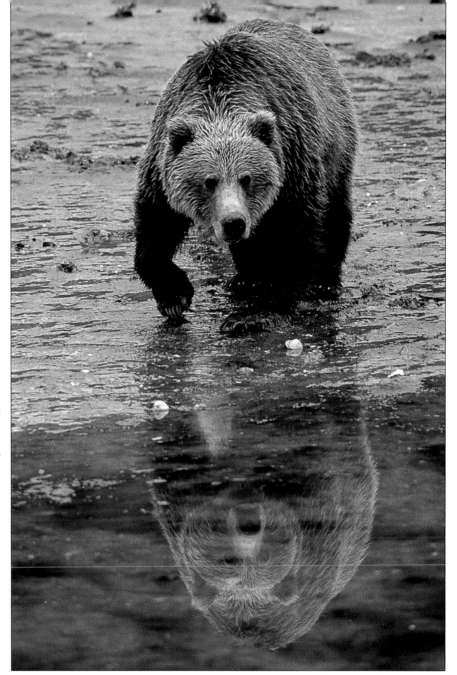

TOP—This Alaskan brown bear is comfortable with people as long as they keep their distance—which is a good idea for other reasons! A 500mm lens captured the bear and its reflection. BOTTOM—The bear allowed its two yearling cubs to join it at the water's edge once it felt comfortable with the proximity of humans.

shelves full of field guides, research articles, and biological studies of the wild animals that they photograph. They also query biologists and researchers whenever possible.

And they do their own field study. Paying attention to animal behavior in the field is an important part of learning about a species. It also adds to the enjoyment of the pursuit of wildlife photography. Take note whenever you see wildlife behavior. And learn to interpret that behavior to become a better wildlife photographer and to gain fascinating insight into the natural world.

No matter what the species or how much you know about it, it also often helps to pursue your wildlife photography at places where animals feel safer with humans. Their response will be different from those of the animals who have been heavily pressured by human activities. While some folks might satisfy themselves with a quick look, the wildlife photographer wants both lengthy and close encounters. Wildlife photographers treasure those special places—usually state and national parks that don't permit hunting—where man and animal can interact in harmony.

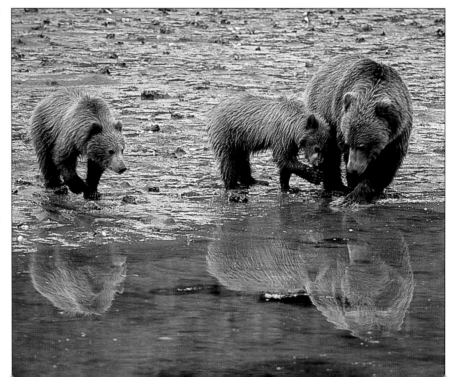

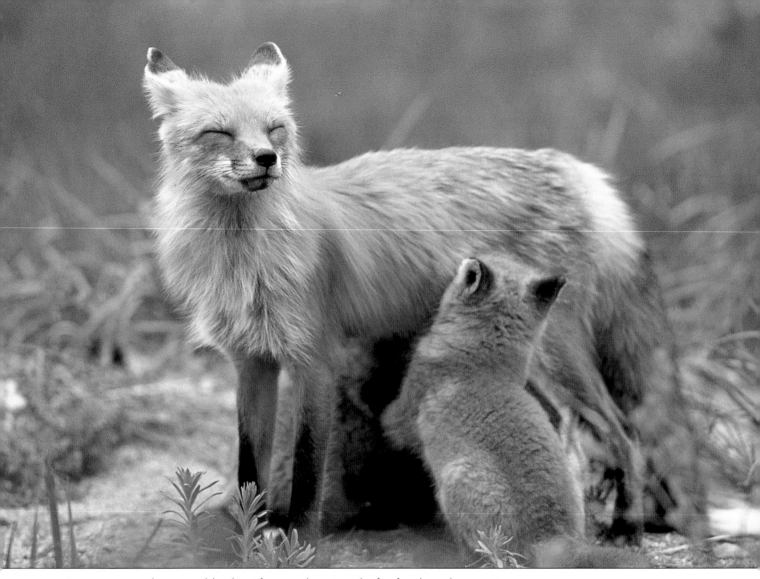

Learning as much as possible about foxes and treating the fox family with respect earned a special privilege when this fox mother nursed two of her young right in front of the camera.

Biologists and naturalists sometimes refer to the animals found at such places as habituated. They consider a lack of fear of humans to be an unnatural behavior. (Those who think that should read the journals of Lewis and Clark.) While the subject of natural behavior could be debated, it's important for the serious wildlife photographer to know that many places exist where wild animals feel more comfortable with human encounters.

The photographer who wants to enjoy better opportunities needs to learn not only how to seek out wild animals to spend some quality time with, but also where to do so.

Do some research about an animal species that you hope to photograph. Learn how, when, and where to find that species. Then go to a place where you can work with it, and apply some of the things that you've learned about those animals; you'll soon find out why the first key to consistent success at wildlife photography is to know your species.

2. know yourself

- Can you survive comfortably in subzero cold?
- Can you tolerate insect bites?
- What are you willing to endure to get pictures of wild animals?

Why should a chapter called "Know Yourself" be included in a book about wildlife photography? Perhaps the best answer to that lies in your response to the following questions. Have you ever:

- seen horizontal rain
- had a 500-pound bull elk threaten to stomp you from three feet away
- gotten "momentarily misplaced" in the big woods
- been followed by a bear on the open tundra?

While the pursuit of wildlife photography doesn't necessarily *require* your participation in any of the above scenarios, they *might* happen. So it helps to be prepared for the unexpected. More importantly, it pays to know your capabilities and

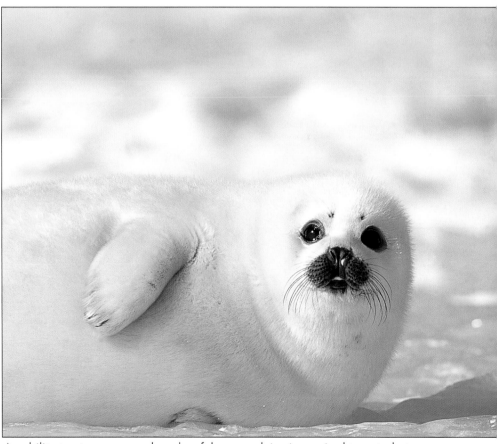

An ability to stay warm and work safely on pack ice is required to get photographs of some species, such as this recently born harp seal pup.

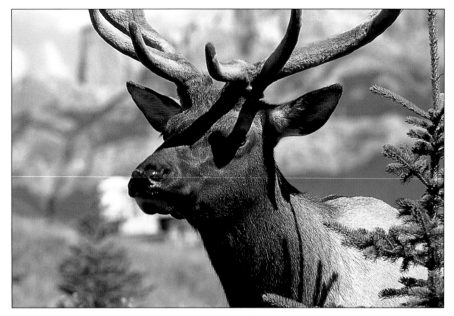

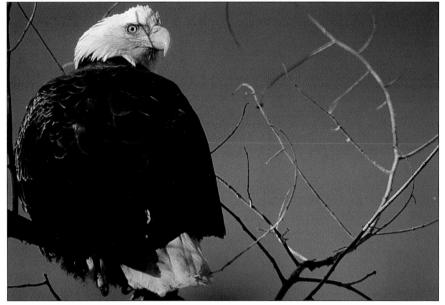

TOP—A 24mm lens captured this bull elk as it threatened from three feet away. My mistake was in not paying attention when someone stuck a point & shoot camera in its face while I was 150 feet distant. After the enraged elk charged, the tree was my only protection until my friend Michael Francis distracted it to allow a safe getaway. BOTTOM— Metering the blue sky guided the exposure when a mature bald eagle perched for a moment on a nearby limb.

limits in case you want to try to avoid such events.

Honestly answering another set of questions is just as important.

• What do you like about the sport of wildlife photography?
• Do you hope to someday be a full-time professional?
• If so, are you willing to "pay the dues" required?
• If not, what are you willing to endure for better photos?

Knowing what really drives you, what makes you want to take a camera to the woods, to the wild—to the cold—is just as important to your consistently getting good results as knowing how to use that camera. Consider the following example.

Over winter in the northern states, bald eagles need open water to catch fish; therefore, a good time to attempt photography of this often-elusive species can be during the dead of winter. With less open water for the birds to work, you narrow your search area. Some of the best places to look for eagles are downstream from dams that keep the water open for limited stretches when it's *really cold*. Dams also chew up some fish to make easy pickings for the birds. With less places to fish, the birds often gather in large concentrations.

One year I sought and found such a place on the Penobscot River not far from Bangor, Maine, just below the Veazie Dam, and obtained permission to set up a blind—an essential not to scare off the birds. (Understand that it's vital not to harass these birds. During winter, wildlife needs to maintain energy reserves for survival. Wasted effort fleeing human encounters can mean death for a bald eagle, just as energy wasted running from a non-caring snowmobiler can kill a whitetail. Anyone pursuing wildlife photography in the winter should respect the survival needs of their subjects.)

That December, a cold snap had frozen the rest of the Penobscot solid. To be sure not to scare off the

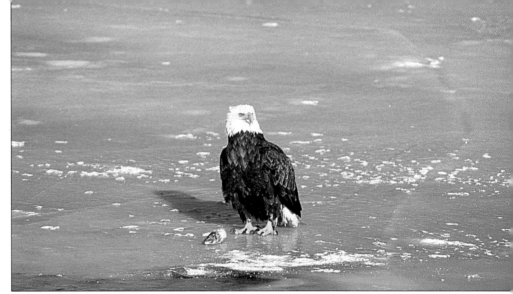

TOP—A bald eagle finally landed within camera range on the frozen Maine river. BOTTOM—Two Alaskan bald eagles fight over a favored perch. Knowing not only where to go but also how to work with a species helps in getting such shots.

five bald eagles that worked that open half-mile you had to be in the blind before dawn when the eagles flew in to perch in tall white pines across the river. You also had to wait until they moved on, sometimes watching them for hours without a bird ever coming close enough to make it worth firing a single frame of film.

How cold was it? The thermometer dropped to 30 degrees below zero every night for close to three weeks. It never got much above 10 below zero, not even by noon.

How long can you sit in 20 below zero temperatures without moving?

One can find a way to endure such cold by learning something about their human capabilities. First, it's important to learn how to dress: layers and layers of synthetic long underwear, wool or modern polyester fabrics that simulate its warmth-keeping capabilities, and a windbreaker; heavy wool mittens over wool fingertip-less gloves over thinner synthetic gloves, with chemical hand-warmers as a backup; layers of socks in large enough, adequately-insulated boots with chemical foot-warmers help to make such conditions survivable.

In temperatures like these, your breath will freeze on the back of the

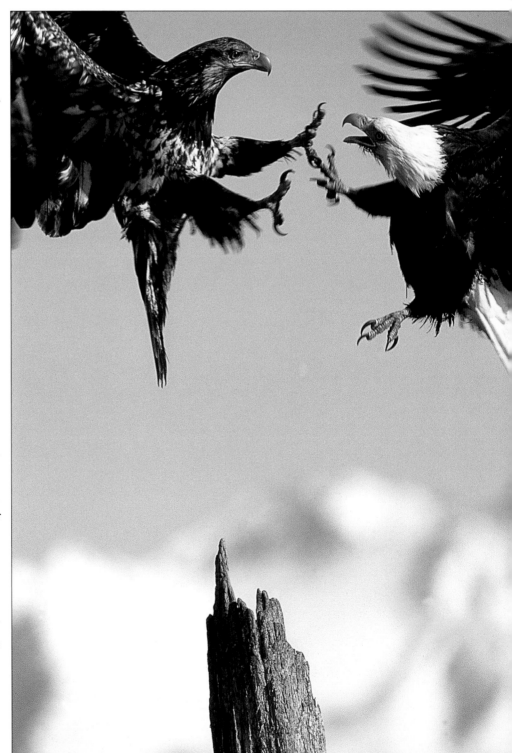

camera. And if you touch that ice with your cheek, watch out! A moustache can also be a lot of fun when pressed against that ice. But the foot problem can be the worst, as your feet are always in ground contact, and that ground is cold! A thick carpet remnant on the frozen ground works wonders.

High-energy snacks, such as chocolate, peanuts, and raisins, help to keep your metabolism going. And a bodily function relief jug—and foregoing coffee until you leave the blind (a thermos of hot chocolate or just plain water is probably much better!)—is essential. It's all part of knowing yourself.

Only a few birds ever flew over to pose in the right place despite many days of waiting and hoping. Their images started my file of publishable pictures of bald eagles.

I've since found much easier places to work bald eagles. But the lessons learned about my physical capabilities, and the discovery of my burning desire to get better shots despite the hardships encountered taught me a lot about myself. And that knowledge has aided in bringing back images from many other parts of North America that otherwise wouldn't be in my files.

Consider your own capabilities and desires as you read the next chapter. For example: how heavy a tripod are you able to carry? And how far are you willing to carry it?

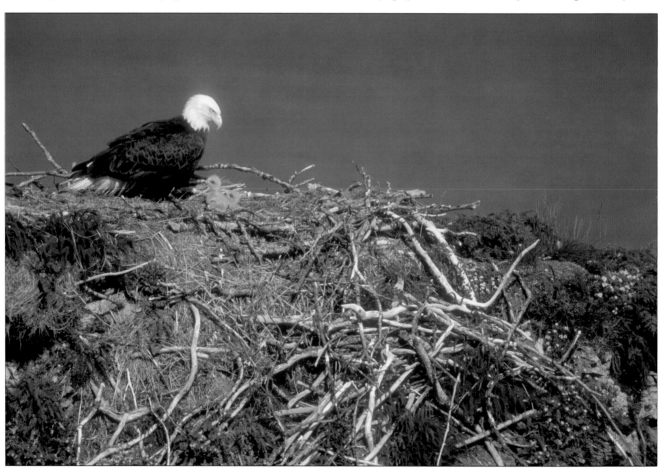

Evaluating the possibilities the year before enabled targeting this Katmai bald eagle nest for the right time during the following nesting season.

4. know your equipment

• Do you really need a long telephoto lens to get wildlife photographs?

• Do pros use autofocus?

• What's the best camera body?

Knowing your equipment starts with knowing what you need to do wildlife photography. The key word in that sentence really is *need*. What you want, what you think you should have, and what you need may all be quite different.

So what do you need for consistently effective results at wildlife photography?

- a rapid firing 35mm camera
- a long enough telephoto lens
- automatic frame advance
- a really good autofocus system
- a sturdy enough tripod

■ THE CAMERA

First, let's consider why the 35mm camera makes the most sense for wildlife photography. Sure, some folks shoot wildlife with medium format stuff. A couple of pros might even use larger format cameras on occasion. Why do they do that? Because having an image on a larger piece of film offers several advantages, not the least of those is the visual impact when an editor pops it on a light table.

Another plus is that you can crop an image out of a larger piece of film—assuming you got close enough for a decent sized image of an animal on that bigger piece of film.

That concern presents the most significant reason why using a larger than 35mm format camera for most wildlife photography doesn't make sense. That reason involves the reality of lens "reach" in relation to the film format size.

Without getting into the physics of it, let's just say that a telephoto lens for a medium format camera has to be nearly twice as long to provide the same "reach" as a lens for a 35mm camera. (For a more complete explanation, see the book *Photographic Lenses* [Ernst Wildi; Amherst Media 2002]). First, consider that a 50mm lens used on a 35mm camera provides about 1X of reach, being the rough equivalent of human vision. Easy math says that a 500mm lens used on a 35mm camera has 10X of reach. But because of the relationship of lens length to film frame size on a medium format camera, a 500mm lens only provides a little more than 5X of reach.

Think about that.

You need to carry a lens nearly twice as long and heavy—and generally more than twice as expensive—to get the same size image of any given wild animal on film with a medium format camera as with a 35mm one.

A large animal makes a possible subject for larger format cameras. This scenic moose photograph was shot with a Fuji GSW 690 on 120 film.

With a moose—not a problem. With a tweetie bird—big problem!

That's not to say that you can't use a medium format for wildlife. I sometimes use a Fuji GSW 690, which shoots a 6x9cm format on 120 or 220 film for pictures of—guess what? Moose.

The relation of format size to lens reach generally goes the other way when you consider digital cameras. Most digital 35mm size camera bodies today have a reach of about 1.5X for any given lens because of the chip size that images are processed on. While landscape photographers lament that their wide angle lens isn't wide anymore, wildlife photog-raphers benefit from all that extra reach. Their 500mm lens just became a 15X!

■ THE LENS

This brings us to one of the most asked questions from folks thinking about getting serious about wildlife photography: "How long a telepho-to lens do I need?" Some folks think that if they only had a 1,000mm lens they could get the kind of images they see in magazines. Wrong.

The Mooseman's third rule of wildlife photography says that no telephoto lens can offset a lack of ability to get close to wildlife. While some reach is essential, as we saw in the last chapter, the real key to con-sistently effective results at wildlife photography lies in knowing the species that you want to photograph so you can find ways to get closer.

But how long a lens do you need? And how much will it cost? That depends.

- What animals do you most want to photograph?
- Do you need top quality, or will you settle for "acceptably sharp" results?
- How "fast" a lens are you willing to pay for?
- How heavy is the darned thing?

Consider that most wildlife steps out to pose in the early morning or late afternoon. The telephoto lens that allows lots of light to reach the film and permits you to shoot in such conditions is called "fast," because you can use a faster shutter speed. Faster shutter speeds tend to pro-duce sharper images from telephoto lenses, as they offset either subject or camera movement. The lowest f-stop number—f2.8, f4, f5.6—that a lens opens to defines that speed. An f2.8 lens is a very fast telephoto lens; an f4 lens is moderately fast; and an f5.6 lens is slow. Anything slower is a dog.

The more light that a lens gathers, the more glass it requires to do so. The more glass, the more mass. The more mass, the more cash you need to pay for it. There's an unfortunate alliance between f-stops and where the bucks stop, especially when you consider that we're talking autofocus lenses.

Consider that a Nikon 500mm f4 autofocus lens costs in the neighbor-hood of $8,000. Also consider that you'll need more gas to get it there, since such a lens weighs about eight pounds.

The tripod to support it weighs perhaps another ten pounds. It's fun lugging all that stuff around the woods. But do you really need such a tripod? Serious photographers know the rule of thumb: use a shut-ter speed at least as fast as the frac-tion made by 1 over the length of the lens. For a 500mm lens, that's $\frac{1}{500}$ of a second. Otherwise, you better be on a tripod.

With a lens that weighs eight pounds, you probably always need a tripod. That tripod better be sturdy enough to eliminate camera shake.

We'll get back to that in a moment. First, the answer to your question: how long a lens is needed? A 400mm to 500mm autofocus tele-photo works well for most wildlife photography. Photographers who specialize in birds often use a 600mm lens. That's a very heavy piece of gear to carry about. And it definitely requires a sturdy tripod to ensure sharp images.

Such a long lens is best used from a blind on stable ground. When pho-

This goldfinch doesn't come close to filling the frame, even with 700mm of tele-photo lens at close range.

tographing from a small watercraft—whether underway slowly, drifting, or even anchored—working with that much glass requires a fast shutter speed to offset camera motion concerns. While a "fast" 600mm lens has advantages in its extra reach over the 500mm that most wildlife photographers seem to be using today, it has disadvantages in handling due to its weight.

If you add a teleconverter to increase the power of any original lens, you can extend its reach. You can get good results with a well-made—read that to mean *more expensive*—autofocus teleconverter. But you will also get a significant reduction in the light gathering capacity of the lens, requiring even slower shutter speeds that compound any camera movement concerns. All teleconverters take at least a stop of light.

You won't be happy with the results from a cheap teleconverter. A decent one costs at least $300. The teleconverters made by the lens manufacturer to match to a given lens or lenses produce the best results. Which teleconverter should you use? Most professionals prefer a 1.4X teleconverter. Even a top quality 2X teleconverter has some loss of sharpness, not to mention the increased problems of camera shake that probably make it the least used.

While longer telephoto lenses have historically been heavier, trickier to use, and more costly, recent technology advances have changed some of that. Canon came out with a line of image stabilization (IS) lenses several years ago. Simply stated, IS technology permits Canon camera users to handhold a telephoto lens at slow shutter speeds and get sharp results. How much slower depends on the lens and the capability of the user, but two shutter speeds slower than before should be achievable by most people.

Nikon shooters who have the AF VR Zoom-Nikkor ED 80–400mm f/4.5–5.6D telephoto lens benefit from a similar technology. The VR stands for vibration reduction. Also designed to offset camera movement, VR technology likewise permits photographers to handhold at shutter speeds that before required a tripod for sharp results.

Nikon says you can handhold their VR lenses for sharp pictures "at shutter speeds approximately three stops slower than you ordinarily could." It's worded that way because, again, individual photographers can handhold at different shutter speeds depending on their steadiness. Using the old rule of thumb math, that means you might be able to handhold a 400mm lens with an unbelievable shutter speed of $\frac{1}{60}$ of a second! Such technology permits photography of animals we could only watch before.

But do you need a 500mm F4 autofocus lens that costs $8,000, or even an IS or VR lens to do consistently effective wildlife photography? Not necessarily. Determining the best lens choice for you depends upon your purpose in doing wildlife photography. If you want to com-

Getting really close to wildlife doesn't always requires a telephoto lens and a heavy tripod.

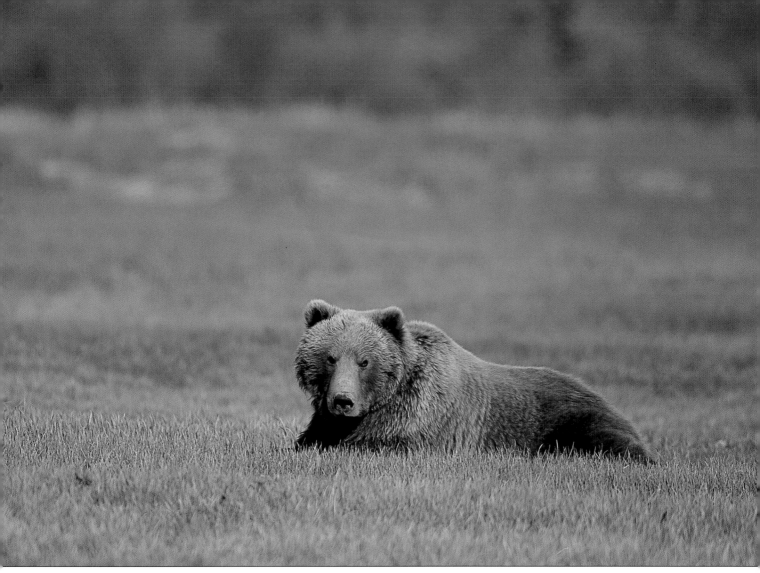

The vibration reduction technology of a Nikkor 80–400 VR zoom lens permitted handholding for a sharp image at $\frac{1}{125}$ of a second for this photograph of an Alaskan brown bear.

pete as a professional with those who use top of the line gear, the answer is yes. If you're learning but want to collect a file of publishable images, or if you plan to remain a serious amateur but want to be able to get some of the same kind of photographs that the pros get, not necessarily. You might even get by with a manual focus camera and long telephoto. But as we'll see in a minute, you'll miss a lot of shots.

Some slower 500mm autofocus lenses sell today for around $700. Are they any good? The short answer is: it depends. You can get professional quality—read that to mean *publishable images*—out of a $700 telephoto lens. But they're slower at light gathering and not as rugged. With telephoto lenses, you do get what you pay for: there are always trade-offs.

Stay away from the mirror telephoto lenses if you're bargain hunting. While they might seem a real deal for the reach you can purchase, they typically have a fixed aperture of f8 and produce rings, or "doughnuts," in out of focus highlight areas.

It's wise to check the photo magazines and Internet reviews for critiques of any lens before buying.

■ FRAME ADVANCE AND AUTOFOCUS

To consistently get great results at wildlife photography you should have rapid automatic frame advance and the best autofocus that you can afford.

Relating some personal experience will tell you why. I started serious wildlife photography with a Minolta SRT 101, which had neither an automatic frame advance nor autofocus. With luck, maybe six wildlife images out of thirty-six frames on a roll of

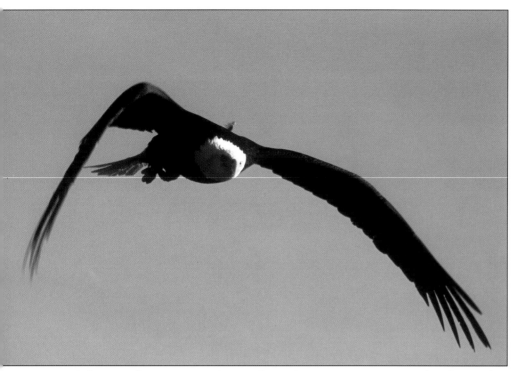

A fast autofocus camera that predicts where a moving target is heading makes images such as this one possible.

film made the files as publishable keepers. We're not talking landscape images—those are much easier to keep more of. But try getting lots of keepers of things with a pulse—animals that jump and run and fly—when you have to cock the film advance and then manually focus for each frame.

Later, with a Nikon F3 and accessory motor drive, that take went up to ten out of thirty-six wildlife frames. Because the early Nikon autofocus cameras significantly limited creativity by only having a dead-center autofocus, I passed on getting one. As we'll see when exploring the subject of composition, using autofocus often affects where you place a subject.

Then Nikon made a fast and effective somewhat off-center autofocus that is available with the N90S. My

keepers went to about twenty out of thirty-six.

Moving up to the Nikon F5 a couple of years later made an even bigger difference. This camera body has both an incredibly fast firing rate and an unbeatable autofocus capability, especially when set in the predictive continuous dynamic mode, which in essence makes the entire screen active and keeps a fast moving subject in focus once locked on with one its five acquisition points. My take with an F5 often approaches thirty-six out of thirty-six!

Canon shooters also have excellent camera bodies with similar autofocus and frame advance capabilities.

It doesn't matter which manufacturer's system you use as long as you use the right stuff. Other manufacturers are catching up to Canon and Nikon.

■ THE TRIPOD

Aspiring wildlife photographers often overlook the importance of the one piece of gear most essential to consistently bringing home trophy pictures: the cursed tripod. Why is it cursed? Consider the downside:

- a leg jams when you need to set up in a hurry
- a leg loosens and slowly telescopes shorter and shorter as you're shooting
- hilly—or worse—mushy terrain makes a non-level platform for it
- a tripod doubles its weight for every mile that you carry it
- it gets tangled in a "wait a minute" vine while you're bushwhacking.

If you want to consistently bring back quality wildlife photographs, you need to learn how to deal with each of them. All serious wildlife photographers use a tripod most of the time. And they learn to love it as much as they hate it.

Why do they love their tripod? Consider the upside:

- It takes the weight of a heavy telephoto lens off their hands.
- If they use a good tripod correctly, they can always make sharp pictures.
- Their opportunity with that moose, deer, or eagle will not be wasted.

To achieve maximum benefits, get a good tripod and learn how to use it.

What's a good tripod? The best answer is to get the lightest and easiest to use tripod and head combination that you can afford—and make sure it provides a sturdy enough platform for the telephoto lens that you plan to use. Just understand that you're kidding yourself if you think you can plop a heavy professional-grade long telephoto lens on a $150 tripod.

Since there are many flavors to choose from, and personal taste enters into the choice, it's best to visit a well-stocked camera store and try out the selection available. That aside, some things do make sense when selecting any tripod for serious wildlife photography. These include:

• The tripod should extend to your eye level without a center post.
• You should be able to position the legs 90 degrees from the head.
• The leg locks should work easily and tighten the legs securely.
• It's best to avoid lever type leg locks if they will get caught on vegetation.
• The head should have a quick release mechanism.

The tripod head can make a huge difference in your always being ready to get the shots. Usable tripod heads for wildlife photography come in three major types:

An Arctic tern returns to its nest. A tripod head that smoothly permits keeping a lens pointed at a moving target should be part of every serious wildlife photographer's equipment.

• the three-way pan tilt head
• the ball head
• the gimbal-type head.

The three-way pan tilt head is the least useful for wildlife photography. While these make great heads for still life and scenic shots, the need to work three levers or handles seriously hampers the wildlife photographer who needs to aim fast at a moving target. Most serious wildlife photographers soon graduate from one to a monoball tripod head.

A wide selection of ballheads is available. On most, the photographer needs to use only one hand on a locking lever or knob. The more you pay, the smoother the operation of the ballhead typically will be. With

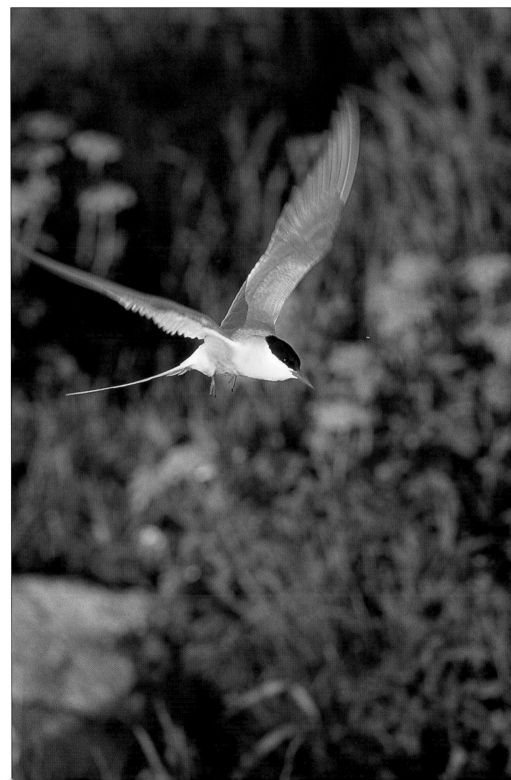

the best precision ones, you can set the tension so that the lens moves freely enough but stays in position even if you let go of the camera entirely. Following a fast moving target becomes a lot easier with a precision ballhead. And panning—following a target while shooting with a shutter speed that often blurs the background while capturing some or most of the subject sharply—becomes much more possible with a precision ballhead.

Some who want a fast action tripod head prefer the gimbal-type heads that became available from Wimberley in 1991. These heads—the Wimberley itself and a smaller version that attaches to an existing ballhead—provide for perfect balance and quick tracking of a moving target. The Mooseman recently became a Wimberly convert after progressing from the three-way pan tilt to a ballhead to a really precision ballhead over a period of years.

The carbon fiber tripods now offered by Gitzo also make a lot of sense for the wildlife photographer who plans to do much hiking. The weight is about half of what you need for a metal tripod of equal stability.

Keep in mind that the heavier a tripod or the more difficult to use, the less likely you will be to use it when you should. But never sacrifice stability for too light a tripod.

Even with a tripod, camera motion can ruin your photographs when the shutter speed is too slow. What's too slow a shutter speed? That depends on the lens length and how rock steady your tripod really is.

It might also depend on unexpected camera shake caused by the mirror in your single lens reflex camera "slapping" up so that the film can "see" the image to be recorded. The mirror that you use to focus and frame the scene has to be moved out of the way before you can take a picture. Some cameras have a mirror lockup mechanism that permits the photographer to get the mirror out of the way and lets the camera settle down before they snap the shutter. While that works great for scenic photographers, it's not often useful for a wildlife photographer. We need to see the animal to be able to push the shutter when the pose works the best, not to mention refocus if the animal moves. About the only time it might help would be for an animal standing perfectly still.

According to George Lepp, the best technical camera columnist I know, writing in *Outdoor Photographer* magazine, mirror slap concerns seem to be the greatest at shutter speeds of $\frac{1}{15}$ of a second. If you want to stay focused on a wildlife subject as well as watch it for the right pose, it's better to avoid shooting at that shutter speed than to lock up the mirror. Even a slower speed might be preferable with an animal that does not move. Of course, if that was the case you could have locked up the mirror. But then you might not have noticed if the animal moved!

A more important tool for the wildlife photographer shooting at slow shutter speeds is a shutter release cable, preferably an electronic one. While a simple mechanical cable release helps reduce the possibility of inducing camera motion when pushing directly on its shutter button, an electrically connected cable that operates both the autofocus and the shutter is available for many modern cameras.

If you're worried about camera shake due to a slow shutter speed and don't have a cable release, try activating the shutter with the self-timer. Most cameras have one so that you can take your own picture. The downside is that, as with the mirror lockup, you might miss the pose or lose focus. If it's adjustable, set the self-timer to operate after a few seconds only to minimize that concern.

The concern that operating the shutter at slower speeds causes camera shake has been significantly reduced on the more modern cameras. The electronic shutters on these cameras often don't really require "pushing" to fire a frame. Learn to use a gentle touch.

Finally, use automatic frame advance as a tool for these situations. Fire short bursts of three or four frames. While camera shake—from either the mirror slapping up the first time or from your pressure on the shutter button—might impact the first frame of a burst, the others often come out tack sharp.

Once you've settled on a tripod and head and a camera and prime telephoto lens, you should learn how to set it all up quickly and how to have it ready to shoot whenever possible. Consistent success at wildlife

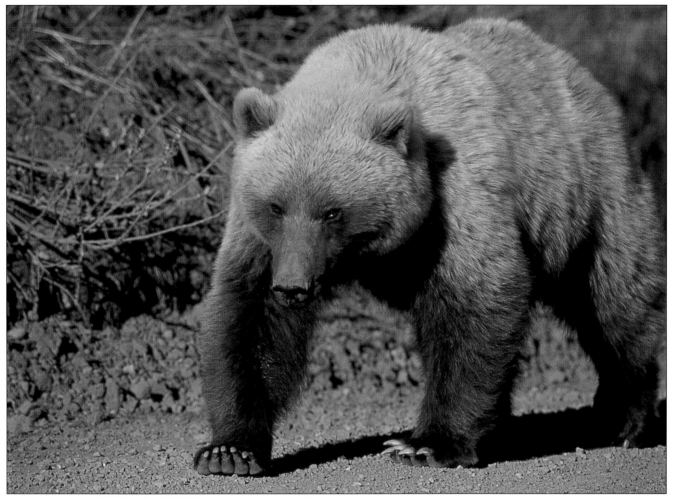

photography requires a total familiarity with one's gear.

Simply knowing how to use your equipment—which buttons to push, what the meter says—is a good place to start. But it's not enough to meet the challenges of photographing most wildlife. Wild animals don't stand around and pose at your command, and when things happen, they often happen quickly. A major difference between basic nature photography and real "camera hunting" is that you have to always be ready or you will miss the shot.

The Mooseman's fourth rule of wildlife photography says that you must train yourself to use your equipment as a reflex action.

Catching this grizzly walking up the road in Denali National Park demanded fast action. You should learn to use your equipment as a reflex.

To reach that point, you just have to pay some dues.

The first step? Read your entire camera manual. Then practice with your camera and tripod in the field, on non-wildlife subjects if need be. Try photographing a pet outdoors. Read photography magazines and books. And practice some more. Maybe take a photography course. And practice even more.

In short, to really know what your equipment can and cannot do you have to shoot a lot of film. Hey, it's fun. Besides, your photo processor will love you. Then edit your work,

as described in chapter 21. Study all your results, learn what doesn't work as well, and figure out why before you toss the rejects. After you've shot with your camera for about a year, read the manual again. You'll be surprised at how much they've added to it.

It also helps if you use the same film all of the time, at least until you learn what that film can and cannot do. Film selection—as well as the difference between film and digital shooting—is a whole other subject.

5. *know your film*

- Should you shoot chromes or negatives?
- Are fast films sharp enough for wildlife photography?
- What about digital acquisition?

Knowing your film starts with knowing what film to use to photograph wildlife. As with your choice in equipment, the better answer to that question depends on your response to several others:

- Do you want to sell the use of your photographs?
- Do you want to make large prints of your photographs?
- Do you want to show your images on the Internet?

Before looking at your answers, let's do a quick review of the types of film and electronic products available that make good media for recording wildlife images today.

For film, we have black and white negative, color negative, or color slide films in a variety of speeds. The speed that a film is rated at indicates

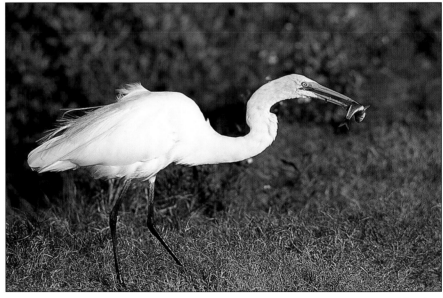

ABOVE—Photographing a white bird in good light doesn't require a fast film, but one that can record the range of brightness with fine grain and good sharpness. Provia 100F film. FACING PAGE—A dark moose in a deep forest environment requires a fast enough film. This one was shot on Fujichrome Astia, an ISO 100 speed slide film.

its light sensitivity—a most important factor when making a film choice for wildlife subjects. You might want a faster film to work with dark-coated mammals in deep forest environments, as compared to pho-

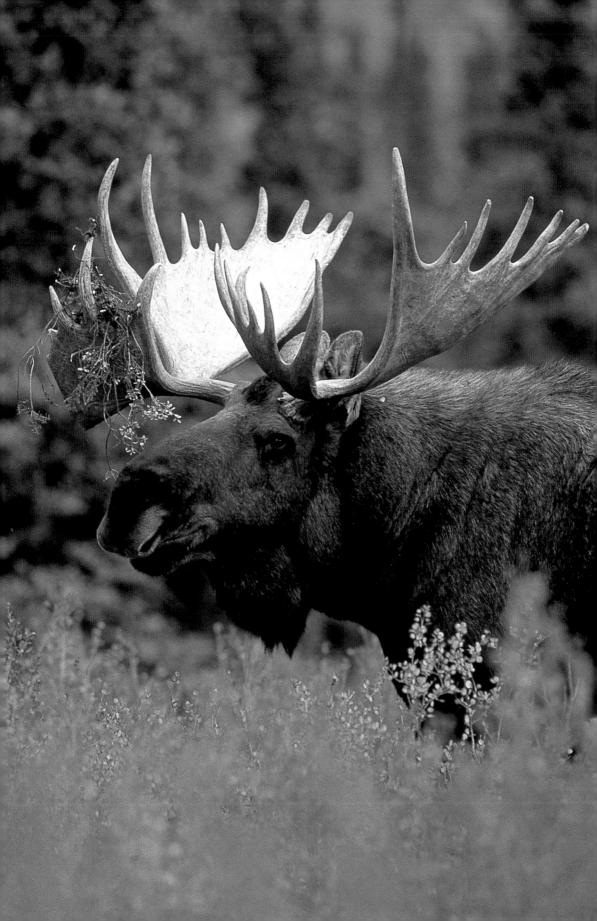

A fine grained film also captures landscapes well, like this view of the Chiracua Mountains, while you're waiting for the sun to come up and the wildlife to show itself. Provia 100F film.

tographing white birds in the Florida sun.

The International Standards Organization (ISO) oversees the system that film manufacturers use to describe film speeds. Those ISO numbers serve to keep us all on the same page. Whether you trust the camera, or fiddle with the buttons to set the "correct exposure," you need to know the film's rated speed. For example, a film with double the speed is twice as sensitive to light, and only needs half the exposure in the camera. To set that exposure correctly, the camera needs to know the film's speed—and that number must be trustworthy.

Modern cameras reset the metering system automatically for a film's speed by reading the DX code on the film cassette. If you have an older camera that you must set the film speed on, be sure to make a change when going from a film of one speed to another or you'll get incorrect exposures. Trust that the modern ISO arithmetic numbers work in place of the older ASA numbers.

Once the film speed is set, the camera's meter can then provide the correct information to guide you in setting an exposure—assuming that it is calibrated properly. We'll look at that subject more closely in chapter 6.

Now let's decide what type of film you should shoot for wildlife photography. Unless you're going to specialize in unique fine art prints—burning and dodging in the darkroom as the "Ansel Adams of wildlife photography"—stay away from black and white film. Unless really artfully done, black and white prints just don't compare to color on the wall. And editors don't pay as much for pictures published in black and white. Conversion to grayscale in Adobe® Photoshop® from a color original provides adequate quality if you want to sell to those low-paying markets.

That leaves two emulsion choices: color negative film or color slide film. Depending on how you answered the questions posed at the beginning of the chapter, it really doesn't matter which one you choose to shoot with today. It doesn't matter, that is, unless you're interested in selling the use of your images to magazines, book and calendar companies and the like. If that's the case, you should probably be shooting slide film. As of this writing, most editors still want "chromes," as they're called in the business.

Shooters for publication generally choose chromes rated ISO 100 or less. While Kodak used to have the market for serious nature photographers with Kodachrome 25 for landscape work and K64 for wildlife and action shooting, many professionals and serious amateurs alike now shoot Fujichrome or one of the E6 emulsions from Kodak. "E6" refers to the development method used for any of these films, a much easier process than that for Kodachrome, which needs special chemicals and patented machines available at only a few locations. Any decent lab can handle E6 in a few hours.

Since I am a member of the Fujifilm Professional Talent Team and am often sponsored for slide talks and workshops by Fujifilm, I am obviously partial to their films. But I will tell you that many good films are available for us to shoot

with today, regardless of who makes them.

A lot of film choice is in the eye of the beholder. We have many flavors available today. While some wildlife photographers like Fuji's Velvia, a professional-grade chrome that is renowned for its "popped" colors and fine grain, I've always preferred the ISO 100 versions of Fuji's professional chrome films, starting years ago with RDP, then Provia, then Astia, and today Provia 100F. The extremely fine grain, accurate color rendition, and sharpness of Provia 100F make it the film of choice for many wildlife photographers today.

And when a much faster film is needed? Several years ago the wildlife professional's only satisfactory choice was to "push" ISO 100 slide film a stop, maybe even two stops—in other words, tell the camera that the film is rated as ISO 200 or 400—and then have a professional lab process the film longer. While many still do that at times, the release of Fujichrome Provia 400F a couple of years ago gave us the ability to photograph with a relatively fine grained film that is sharp, not contrasty, and provides accurate color rendition to most people's eye.

Again, film flavors are a matter of choice based on individual perception. All I can tell you is that I've shot hundreds of rolls of Provia 400F, and have had cover shots on both books and magazines published with it. Combined with the newer technology IS or VR lenses that permit a photographer to handhold a long telephoto at slow shutter speeds, this film has permitted wildlife photographers to bring back images of animals that they could only watch before.

If your goal is to sell or make prints for yourself and friends, you might just want to shoot color negative film. These films go by the name "color" at the end—Kodacolor, Fujicolor, etc. The best part of shooting a color negative film is that the grain has always been finer than that of

When a much faster film is needed, Provia 400F is my film of choice. It's fine enough grained and records colors well. This image made the cover of my *Moose Watcher's Handbook* (R. L. Lemke, Inc., 2002).

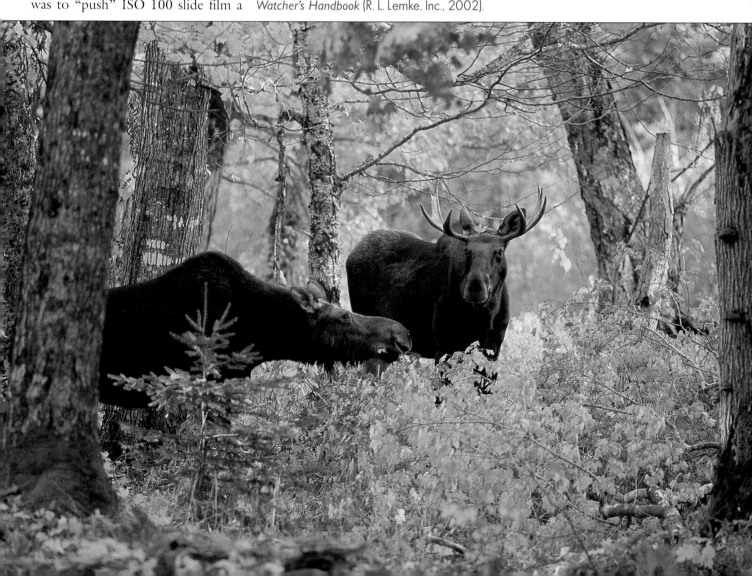

This digitally acquired image was shot with a Fuji S1 camera body.

slide films, so you can shoot with faster speed films and still get excellent results. Films with ISO ratings of 200 are super fine grained, and films with a speed of 400 and even 800 are still quite fine grained.

Color negative film also is much more forgiving of exposure errors, as it records a wider range of light to dark. Referred to as wider latitude, that makes printing from a negative that's off by even two full stops of exposure possible. You could never do that with a slide film.

Making a print from a negative by the photographic process is also usually less expensive and easier from an

original negative. Therefore, wildlife photographers who sell their prints at art shows generally work with negative film, since photo process labs can inexpensively knock out a large number of copies. That's not to say that you can't make an internegative from an image originally shot on slide film. It's just that the result becomes the second generation of the image, and the print the third.

And then there's digital. If you're shooting with a digital camera, you record the images on either a flash-card or microdrive (there are a variety of types available), and then transfer the electronic image files to a

computer's hard drive or to CDs or DVDs.

With the film scanning and computer printing technology available today, it really doesn't matter that much what you originally shot an image on if you're not looking to publish your work. You can get a great inkjet print from scanning either a slide or a negative, as well as from a digitally acquired image of adequate file size. And most of the professional model digital cameras available today have megapixel capabilities that provide file sizes adequate for any publication use.

The better desktop film scanners now available produce files of 50MB or more from a single image, rivaling

the drum scanners that used to be needed to get publishable images from film. If the photo editors that you sell the use of your images to are trusting of these newer technologies and your work, you can sell images on a CD or a DVD as scans from original film or perhaps digitally acquired files. I regularly sell a number of images by scanning original chromes and sending a CD of high resolution TIFF files to editors.

The digital world changes before ink dries and acquiring, scanning, and working in Adobe® Photoshop® are all worth a book in themselves—see *Beginner's Guide to Adobe® Photoshop®, 2nd Ed.*(Michelle Perkins; Amherst Media, 2003) for a good start. Therefore, we'll limit the subject of digital imagery in this book to those few remarks.

Regardless of the film you choose to shoot or the digital camera that you use, it's important to shoot it enough, until you learn its nuances: how it records whites and blacks, what its latitude for recording highs and lows is, how contrasty it is, and more. How does it handle colors? Do they record as they appeared to your eye?

As described in chapter 21, knowing your film includes looking at your work critically. Look at your slides critically with an 8X loupe on a good light table. If you're shooting prints, be sure that the lab making those small machine prints knows that you're doing nature photography. Most of those machines are set to print human facial tones—not bears or moose! Look at the negatives and learn to read them to make sure you're getting good density in the image. And if it's a digital file, learn how to read the histogram that tells you about the quality of an image and its dynamic range.

Know what your film or image recording media can do, and you'll consistently bring back trophy wildlife pictures.

A Nikon Super Cool Scan 4000 was used to turn this image of a musk ox, originally shot on slide film in the Northwest Territories, into a publishable quality digital file.

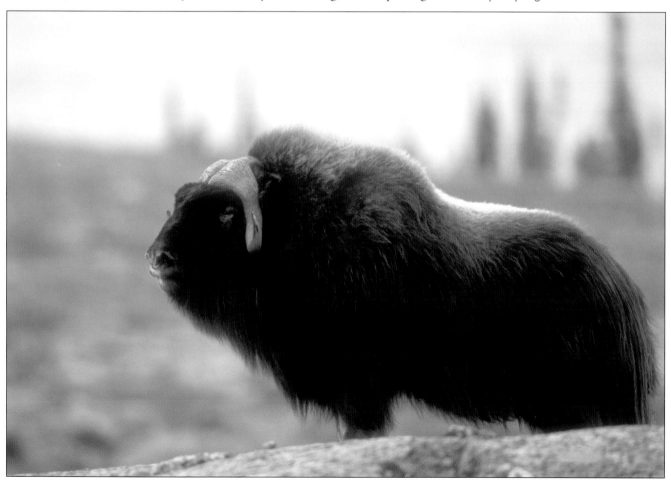

6. meters matter

• How do you expose for a loon that's both black and white?
• Can you trust the camera's meter?

A most critical element for successful wildlife photography, assuming that you've found a subject to point your camera at, is the proper exposure of your film. You'd better hope that you've got the exposure right when a black bear steps out of the woods!

All but the oldest cameras have automatic programs to set exposures using some witchcraft called matrix or evaluative metering, or another such name that implies it's all done with smoke and mirrors. While it's true that all 35mm single lens reflex (SLR) cameras do have mirrors—not to mention quite accurate exposure meters in them—setting the right exposure isn't always as easy as camera manufacturers would have you believe.

The Mooseman's fifth rule of wildlife photography says that it really does matter what you point the meter at.

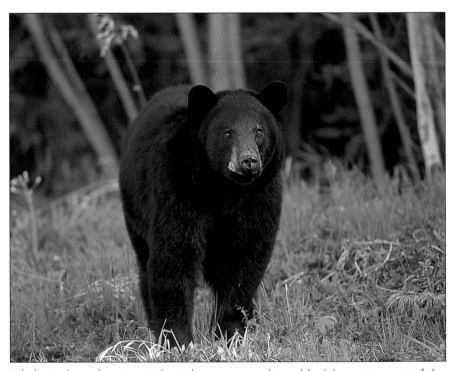

It helps to know how to set the right exposure when a black bear steps out of the woods.

Show of hands: how many of you really believe that all you have to do is to pick a program mode and the photo gods will take care of the rest?

Let's call that the smoke and mirrors syndrome.

Think about it this way: The programmed exposure modes are great

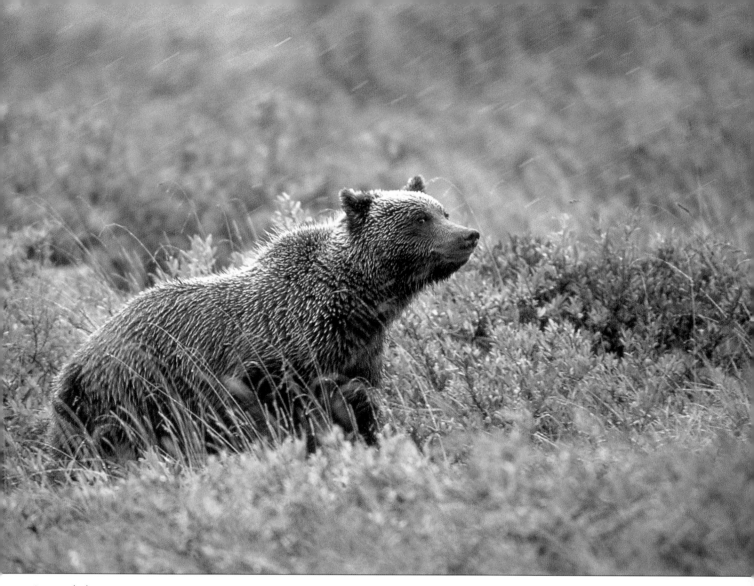

A grizzly bear poses in an average scene.

for many things, but not for learning. Do you have a clue as to what the camera is doing? Most of the folks taking the wildlife and nature photography courses I've taught over the years actually believe that they only need to point the thing at a subject while in a program mode and that the camera will do the rest. The problem is that they miss the words in the manual that say that this works best for photographs of "an average scene."

You should learn to shoot with your camera in the manual exposure mode. That's right, turn off all the fancy program jazz you paid for (unless, of course, you never mess up exposures, in which case you should skip this chapter entirely).

It is true that the newer SLRs have programs that minimize the problems encountered when you point a camera at a scene that is not average. But most people don't know a really non-average scene when they see one. And so they don't know when to trust those fancy programs and, more importantly, when not to.

Adding to your problems is the fact that many wildlife photography opportunities don't even come close to being average scenes. Think about it. Is a moose in a brightly reflective pond an average scene? What about an immature bald eagle against a light, overcast sky? How about a white-tailed deer standing against a dark spruce forest? Or a black bear anywhere? How do you expose for a loon that's both black and white?

So what is an average scene? One that reflects an average amount of light from the various elements that fall in the frame of the picture that you seek to record on film. It's as simple as that.

An average scene reflects light similarly to what is called an 18 percent gray. Let's skip all the science

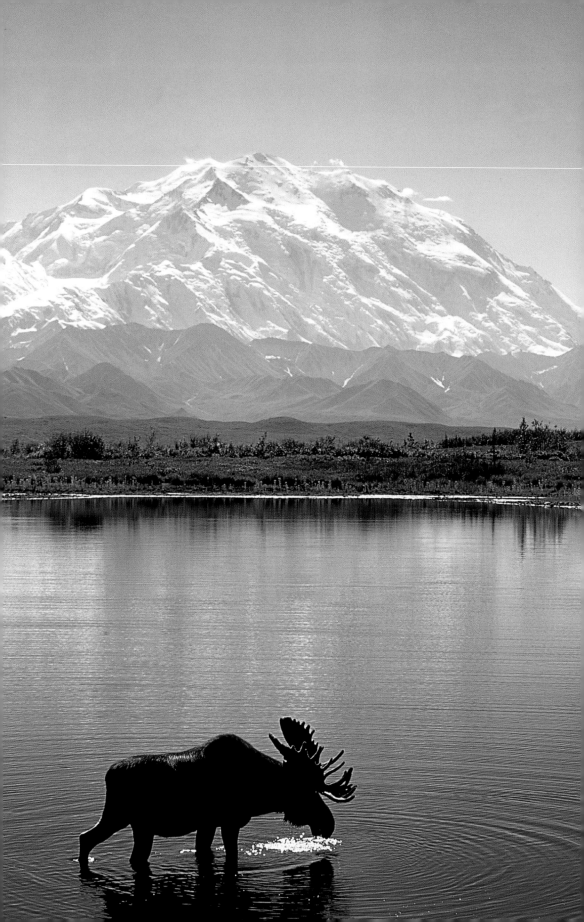

and just think of 18 percent gray as reflecting an amount of light halfway between the light reflected by an all-white object and the light reflected by an all-black object. While that's not totally accurate, that's how it works.

All camera meters are calibrated to record the light reflected from an 18 percent gray card for an average exposure. If you're serious about wildlife photography—and especially if you shoot slide film, which has less forgiveness of exposure errors—you ought to get a gray card and learn how it's used. I never leave home without one and never miss an exposure. Well—almost never.

You can buy a gray card from most well stocked camera stores. And it's pretty easy to use one. Hold the card

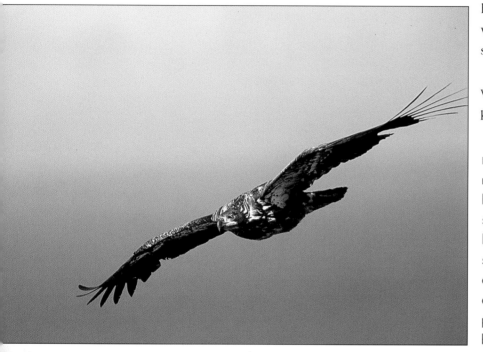

FACING PAGE—A Denali National Park moose stands in a scene that's anything but average. LEFT—The light overcast sky in the top half of the frame shows a lot more light to the camera's metering system than does the immature bald eagle. BELOW—The common loon presents an uncommon challenge for the photographer: a subject that's both black and white.

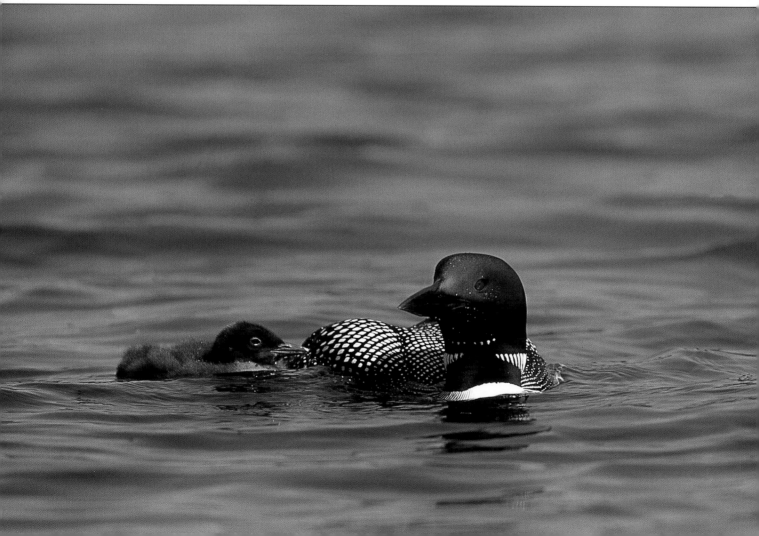

Meter a gray card in the same light as the subject. It helps if your subject stands next to it!

in the same light as your subject and meter from it. Just watch out for tipping the card into the sunlight too directly or letting it fall into its own shadow. Hold it evenly in the light. And don't worry about focusing on it. Just be sure it fills the light-sensing areas of your viewfinder.

You need to know how the camera's meter reads the different parts of the picture. Most cameras over twenty years old have limited center-weighted meters that select about 75 percent of the exposure information from a 10 percent or so area in the center.

Later camera models offer a spot meter as well—even down to a 1 percent spot in the center of the camera. The latest models enable you to move that spot around with the autofocus acquisition point.

A spot metering method combined with awareness of the gray card concept is what many experienced wildlife photographers use. When they meter a "natural gray card" with a telephoto lens (see chapter 7), they can sometimes meter off the back of an animal! We'll explore how to do that in the next chapter. For now, just understand that if you use the concept of 18 percent gray as a starting point, knowing what the meter is saying when you point the camera at a non-average scene becomes much simpler.

The lens length you're using also matters. Meter with a center-weighted meter behind a 400mm lens, and you'll wind up setting an exposure for a very small area, similar to using a spot meter. Try using a spot meter setting with a wide angle lens, and you'll be getting the information from a larger area in the scene. While that might not make a difference, it could, depending on the scene.

The more modern cameras have meters that take into account various parts of the viewing area and weigh those into an exposure calculation, generally depending on what the camera "thinks" the most important elements in the scene are. Evaluative and matrix metering methods take into account a variety of information: scene brightness, scene contrast, and the distance to the focused subject (if you're using a lens that can provide that information). They also take into account different segments of the scene, weigh the reflectance of whatever you're focused on, and yada, yada, yada.

Smoke and mirrors! That works great for average scenes and some of the trickier ones. But don't ever believe that you'll get a proper exposure when your target is a black bear in a snowstorm. Not that you'll likely ever see that—bears hibernate, remember? But if you did see it, wouldn't you like to meter it right?

On most of the newer cameras you can select from center-weighted, spot metering, or an evaluative or matrix metering method. Check your camera manual to learn the types of metering it employs.

What about using an incident light meter? Some folks do. But things often happen really fast. You need to react quickly. You can do that better with the gray card system.

Here's a test: consider that black bear in a snowstorm. The bear reflects minimal light, while the snow reflects all of it. If you meter the bear to set your exposure, the snow will be horribly overexposed. If you meter the snow, the bear will be a lump of coal in your photograph.

The answer? Look for something that reflects an average amount of light and meter from that to manually set the exposure for a subject that's in the same light. That's right. Turn

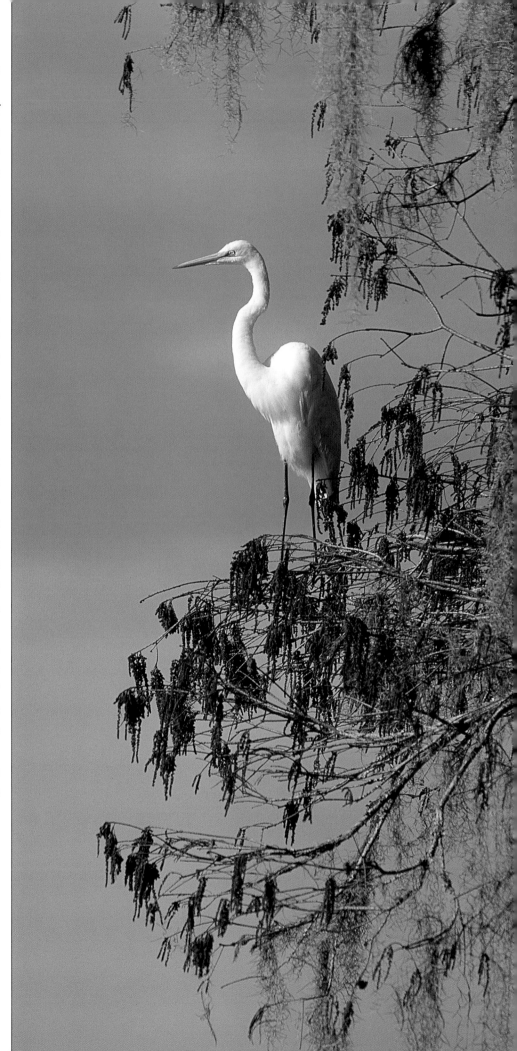

off the fancy program modes, go manual, and meter your gray card.

Metering the gray card instead of the snow will tell you to open up the aperture to let more light hit the film. Then open up a half stop or so to record detail in the fur of the bear.

We'll discuss other such species adjustments in another chapter. For now, just think about the reflection of light off of snow. You cannot totally trust any camera meter when it sees that much light coming at it. The meter is "blinded" to the lesser amount of light reflected by almost any subject.

You don't know how to set your camera manually? The math scares you?

Here's a simple way to get past that. Take the lens off and look at the size of the opening as you rotate the aperture ring (assuming your lens has one—if it doesn't, find one that does). Note that the smaller the hole, the larger the number f-stop that you've set the lens at. Obviously, the smaller hole lets in less light.

Now set the aperture ring at f4. Then set it to f5.6. See how the hole just became smaller? It actually became half the size. That means it will let in half as much light as at the next larger full f-stop of f4.

No matter what lens it is, the amount of light that the lens allows

The longer the lens, the less area a camera's meter covers. But even with a long telephoto lens and a spot meter, you could overexpose the egret in this scene depending on where you take the reading.

to reach the film decreases by one half when you change the aperture from f2.8 to f4, f4 to f5.6, f5.6 to f8, f8 to f11, and from f11 to f16.

Next, think about what happens when you adjust the shutter speed on the camera. A faster shutter speed, say $\frac{1}{500}$ of a second, lets in half as much light as that of $\frac{1}{250}$ of a second. That makes sense, doesn't it?

So if you meter the gray card and the camera meter says that you need more light, you can either:

- open up the lens to a wider aperture (assuming it's not wide open)
- switch to a slower shutter speed.

If it says you need less light, go in the other direction with either or both the aperture opening and shutter speed. It's as simple as that.

Practice setting your camera manually for different exposures, and you'll soon feel a lot more comfortable at it. And don't let the mumbo jumbo of the numbers get you bogged down. If you forget what to do, just look at the lens opening as it changes and think about how the shutter speed similarly affects the amount of light reaching the film.

Once you know what's going on inside your camera as the program modes are changing the aperture or shutter speed, you might want to rely on some of its witchcraft for the average subjects and scenes. Someone once said that the matrix meter in a Nikon F5 has thousands of scenes programmed into its onboard computer that help it select a proper exposure for any scene you might

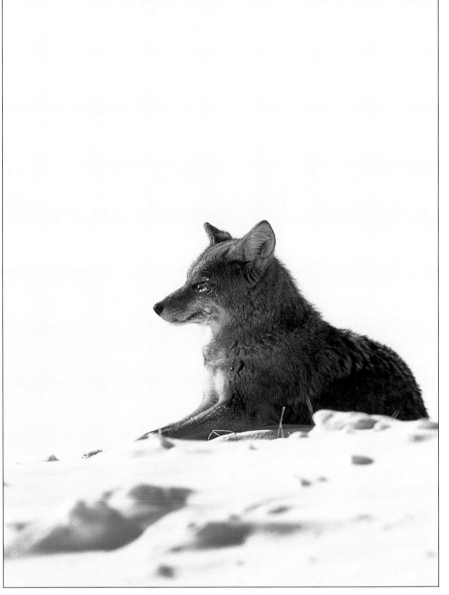

Even an average gray coyote contrasts greatly with brightly lit snow. Manually spot metering on the coyote insured an exposure that captured detail in its fur.

encounter. And while that's absolutely true, I know ten subjects that aren't in that computer, and I shoot them a lot!

That's not to say that the science used in today's state-of-the-art cameras isn't very good. It is more than good—it's phenomenal. On the F5 and other models, the meter even knows what you're focused on. But despite all the science, it still doesn't know exactly what it is that you want to photograph or how you want it to look. Always remember that.

Strangely, few wildlife pros carry gray cards. Most rely on their experience at watching light reflect off of "natural gray cards" that they meter in the same light as their subject.

But if they don't have a real gray card, they're really only guessing, aren't they?

Use The Mooseman's 18 percent gray method to fine-tune your exposures in concert with all the witchcraft and you'll never miss. Well—almost never.

7. natural gray cards

- What natural elements can you trust to meter from?
- Is a moose calf a "natural gray card"?

Gray cards exist throughout the natural world. The wildlife photographer who wants to be sure of his or her meter readings in order to shoot with total confidence at dead-on exposure settings should make it a practice to test the rocks, tree bark, seaweed, leaves, grass, sky, and other natural elements of each place worked.

Meter the gray card in the same light as the natural element that you want to test. Find the things that reflect light just as a gray card does, and you'll then be able to use them to meter from when an animal gets into the scene.

Some reliable natural gray cards include:

- middle-toned blue sky directly opposite the sun
- middle-toned green grass in the spring and summer

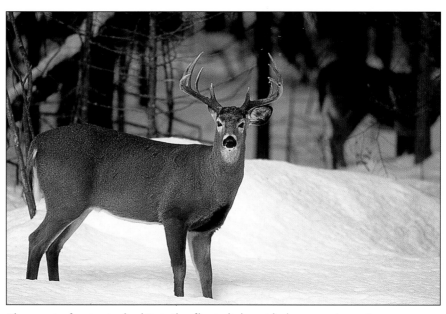

The coat of a typical whitetail reflects light with the same intensity as a gray card—winter or summer.

- average reflectance autumn leaves, either yellow or red
- middle-toned hardwood tree bark.

Note that you should look for the middle tones in all cases, not the real dark or the real light stuff. Try it yourself with your camera's meter. Test the light reflective qualities of some natural features that fall in the same light as a gray card to learn what you can and—just as importantly—cannot trust.

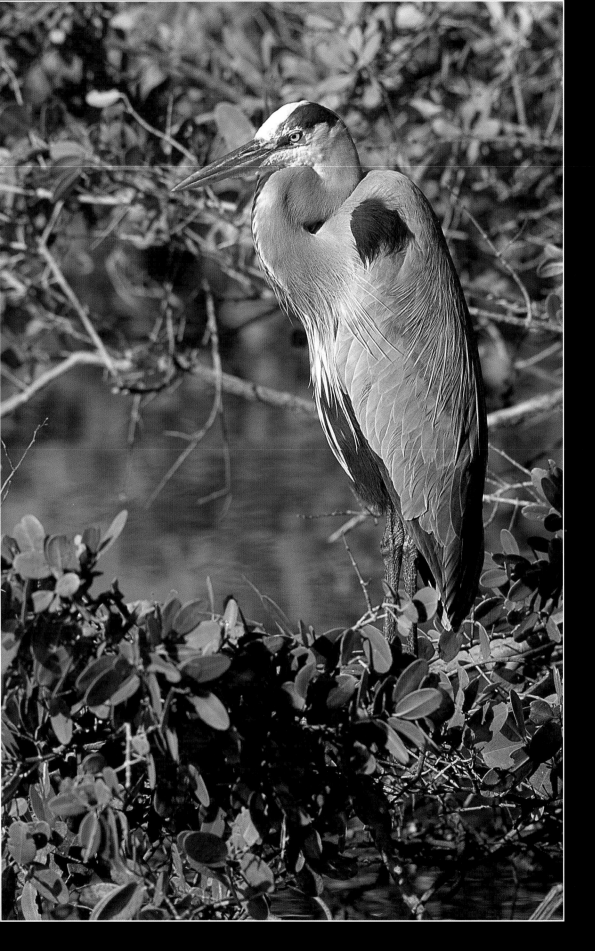

FACING PAGE—A great blue heron makes a great natural gray card—anywhere, anytime. TOP RIGHT—The fur of a bison calf reflects light the way that a gray card does until it's a couple of months old. BOTTOM RIGHT—A young moose calf makes a favorite natural target for spot metering.

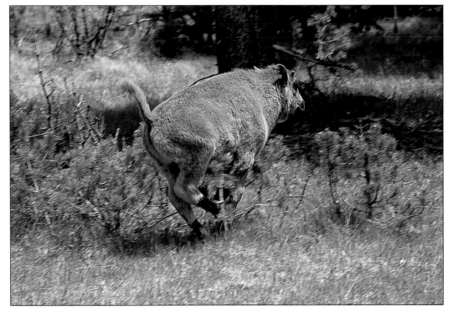

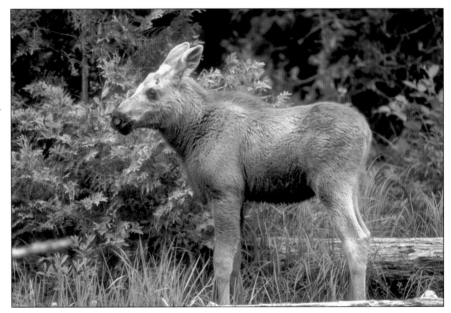

Natural gray cards especially come in handy when you cannot get close enough to meter an animal directly or when there isn't enough time to figure out a tricky exposure. I always check for them before the action starts when working in any new area; it's vital to do this when working from a blind. You can't shove your hand out in front of the lens and wiggle a gray card around once an animal is in your viewfinder. But if you've found something—a rock, a patch of grass, a tree stump, whatever—in your field of view, you can spot meter that to set an exposure with total confidence.

And what if there are no natural gray cards in the scene? You can still make use of something out there to base your metering from. For example, the needles of most white pines reflect one stop less light than an average scene. And so metering them will call for a stop too much exposure for an average subject. Use that knowledge to adjust from a reading taken off a white pine in your scene by "stopping down" for one stop less exposure to record a white-tailed deer standing beneath it.

Or you could spot meter right off the back of the deer. Why? Because most whitetails reflect light just like a gray card does, whether in their summer or winter coat. Unless it's a really darker-coated animal, it works fine.

You do have to beware of some seasonal adjustments. While a great blue heron makes a great gray card any time of year, some animals lighten or darken. Others darken with age: a bison calf reflects light like a gray card until it's about two months old. Then its coat begins to darken gradually, until it's as dark as its par-ents by its first autumn. The coat of a moose calf does the same thing. That animal definitely makes The Mooseman's list of natural gray cards.

8. species adjustments

• How do you set an exposure for a bald eagle's white head?
• Should you bracket exposures?

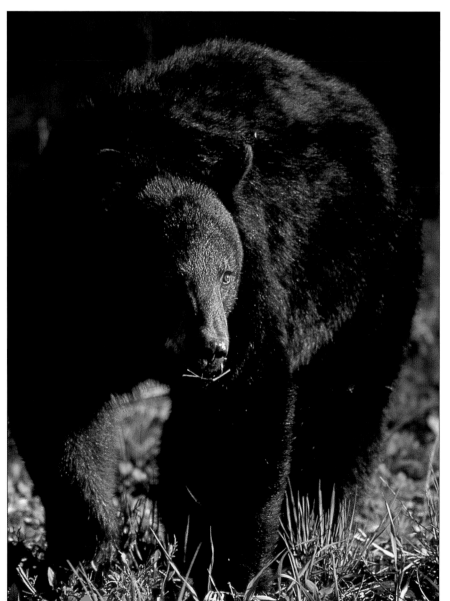

The description of how to set exposures using the 18 percent gray method works for many wildlife subjects. As you saw in the last chapter, it works especially well for mammals and birds that reflect light with the same intensity that a gray card does.

What about the ones that don't? Remember the black bear in the snow? In that case, we added more light to the exposure by opening up the lens half a stop. We could have also used a slower shutter speed, right? Many modern cameras have settings that permit changes of either the aperture or the shutter speed that result in exposure differences of one-third of a stop. That just happens to be the smallest change of exposure that most people notice.

Even in bright sunlight, a black bear doesn't reflect an "average" amount of light.

White egrets reflect significantly more light than the dark leaved mangrove trees commonly found in their environment, especially in bright sunlight.

Even without the snow, a black bear needs more exposure than a subject with average reflectance. Black bears in the shade or overcast light require even more of an adjustment from an 18 percent gray reading, perhaps as much as a full stop more.

Just remember that if you open up that much, anything lighter than gray will blow out—badly. It's sometimes a choice between getting detail in the subject, and not blowing out the highlights. Some photographers say that they expose for the most important highlights, especially on slide film. That's because overexposed slides generally look worse than underexposed ones.

That raises the question: should you bracket your exposures? Bracketing means to shoot at different settings for the same subject in the same light. You shoot one frame at the "correct" exposure, one "under" that, and one "over" that. You could use any increment, even a complete stop under and over.

Bracketing slide film can make sense. Bracketing negative film, with its wider latitude that already allows for at least one stop of exposure error, doesn't.

Bracketing helps when you have a scene or a difficult-to-expose-for animal in a stationary position and a static pose. Otherwise, it's generally preferable not to bracket wildlife

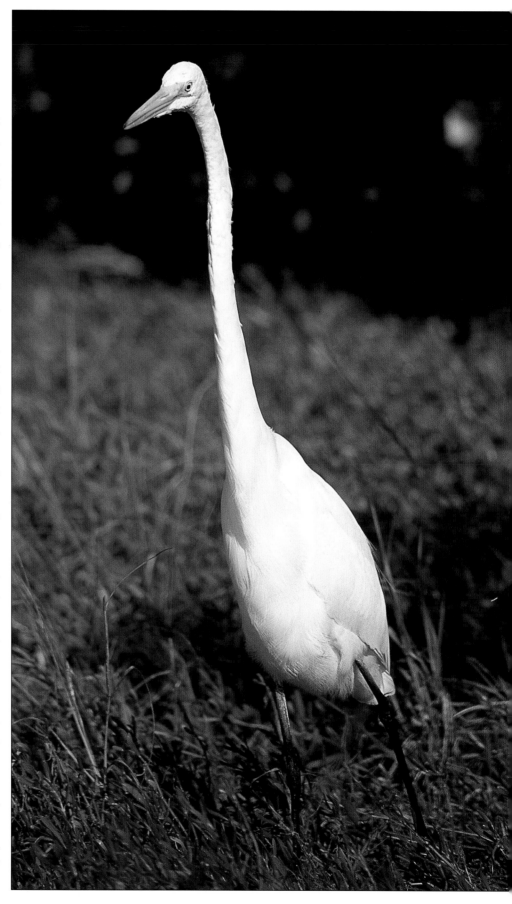

The Atlantic puffin requires stopping down from a gray card reading to set an exposure that does not blow out their white feathers.

photographs. Why? Because you're going to miss some exposures if you bracket all the time, and if you miss on the decisive moment—the best pose or the best behavior—you've missed the shot. The Mooseman prefers instead to use the 18 percent gray method, shoot dead-on accurate exposures by adjusting for the subject, and to never miss. Well— almost never.

So with the black bear in the snow, we exposed to strike a balance between blowing out the snow too much and getting detail in the bear's fur and face—the most important highlights in that picture. A black bear in bright sun, with highlights reflecting off its fur, usually looks good with a half stop more exposure than needed for 18 percent gray.

A number of other wildlife species present similar problems. Consider the bison. Have you ever tried setting an exposure for a bison in Yellowstone National Park's fall settings? For starters, the yellow grass reflects a half stop more light than a gray card. To get detail in the coat of these dark animals in bright sunlight isn't much of a problem. You can generally shoot on a gray card setting. But if it's an overcast day, open up a bit.

The egret family presents a reverse problem—concern for blowing out the detail in their feathers. Trying to photograph an all-white bird sitting amongst dark mangrove trees in bright Florida sun offers another great example of when you cannot trust an automatic exposure setting. The mangrove leaves reflect one stop less light than 18 percent gray, while the birds usually reflect at least two stops more light. From a gray card setting, stop down for less exposure by one-third if in the shade or overcast light, or two-thirds in bright light.

Loons and puffins and other similar birds present a unique challenge, being both black *and* white. Since it's important not to blow out the

white on either bird, stop down one-half to two-thirds of a stop from an average exposure. You'll lose detail in the blacks, but it's better than blowing out the whites.

Be sure to look for a light hitting their eyes. The trick with common loons is to shoot with a low sun angle to show their red eye or when they tip their head into the light. With puffins, it helps to shoot as they tip their head to get a catchlight in their eye.

Mature bald eagles also require that you stop down a half to two-thirds of a stop from an average exposure, depending on how bright the light is that they're in, so that you capture detail in their white head. Photograph them against a blue sky or forest background for the best contrast.

Many other wildlife species will require an adjustment for the best exposure—especially on slide film, which is more demanding. The trick is to notice the difference in reflectiveness of your subject from an 18 percent gray and make an appropriate adjustment.

If you have access to some pets to work with, consider experimenting at setting exposures in different light with both an all-black and an all-white dog or cat. With a bit of practice, you'll know just what to do when that black bear does step out of the woods beside you—photographically, anyways!

Setting an exposure to record detail in the head of a mature bald eagle often results in less detail in its brown feathers. But it's better than blowing out the tones on the head, which is the most important highlight.

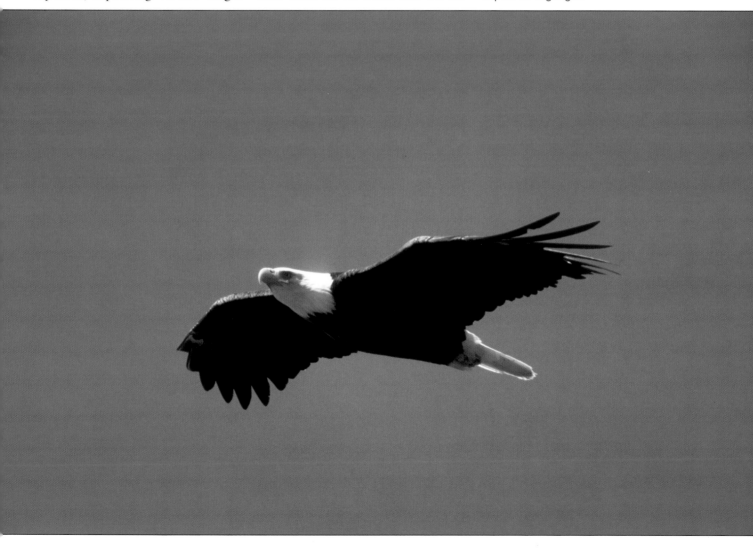

9. metering after the fact

• What can you do if you shoot a rare encounter with an animal with the wrong exposure?

The camera's meter said NO when the big cat stopped and looked back at the lens. But you had to try to get its picture! How many bobcats have you ever seen in the wild? Did they hang around to pose?

Trust that the process described below took far less time than it's going to take to read about. How long do you think the bobcat stared at the camera as the sun set at the Moosehorn National Wildlife Refuge in Maine that June evening? That's the whole point: if you have to stop to figure it out, you'll miss the shot. As it so often does, the whole day's camera hunting on this occasion came down to a matter of mere seconds.

The first thing to do was to figure out how to hold the camera as steady as possible. The answer: open the car door a bit to get the angle for the shot, and rest the camera on the

On rare occasions, consider metering after the fact. When an animal steps out unexpectedly, shoot at a fast enough shutter speed and check the f-stop later.

open window. Shooting through the windshield was definitely out: the curvature of the glass made for too poor an optical quality, to say nothing of the dirt. While you can shoot through things that are within the

minimum focusing range of a telephoto lens—a blade of grass or even a tree stem that falls so close to the lens that it doesn't show—curved glass distorts an image badly. And dirty curved glass is worse.

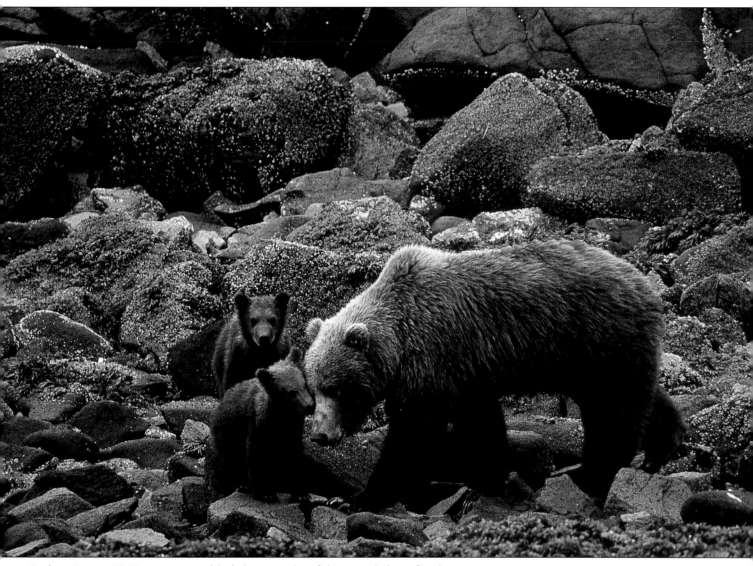

Pushing Provia 400F one stop enabled photography of this grizzly bear family in low light.

I eased the door open as quickly and as smoothly as possible without any abrupt motions. The bobcat just stared at the camera. Oh, it saw the door move all right, but it was curious about the big camera rig, especially the giant eyeball that was looking at it.

I slid out behind the door, crouched, and cranked the shutter speed up to $\frac{1}{125}$ second while resting the barrel of the heavy telephoto lens on the open window of the car door.

Of course, the camera meter still said NO. But it was pushing the envelope to hold ten pounds of camera and lens steady while leaning it on a wobbly car door at that shutter speed. A slower speed would surely have wasted this rare opportunity.

There was no time to consider setting up a tripod. The bobcat would never have stayed around for that. The tripod was in the backseat: the day was nearly done, and the light was too low for the intended target

species—black bears out after the first grass at green-up.

I ignored the meter, composing and focusing manually before I squeezed the button on the electronic shutter release cord. Luckily, the cord was still attached to the camera: because these cords permit shooting without touching, and thus shaking, the camera, its use can be essential in bringing home such a shot.

The big kitty ran at the first shutter click. The second shot showed only its east end headed west, and trees hid its head. But sometimes you only need one.

You're probably asking: how did he get an image if the camera meter said NO? As we've already seen, the meter in my camera—and in yours too—is calibrated to guide exposures for "average" scenes based on 18 percent gray. The area metered for this shot had a lot of typical Maine woods in it. And typical Maine wood just isn't an average scene. Because of spending some time in the past metering those woods I knew that they reflect from one to two stops less light than an average scene.

I also knew that an f-stop equals a shutter speed in its affect on the film. The bobcat read $\frac{1}{125}$ second because the meter was being fooled by the darker background. To know for sure, I ran to the spot after the bobcat left and metered off of a gray card. And the camera's meter said YES!

But what if the after-the-fact metering had said that there wasn't enough light? I was prepared to have that special roll of slide film processed to match the exposure setting required. It's all part of knowing your equipment and film and what they can do, no matter what the camera meter says!

While it's not a good idea to make a practice of metering after the fact, for some rare chance shots it works. If you find when you meter the light after photographing a subject that you didn't have the right exposure, you can have the roll push or pull processed. Pulling means to have it processed for less than the rated speed. Pushing, as described earlier, means to have it processed for faster than the rated speed. Push or pull processing generally refers to slide film. With color negative film, you could probably eke out an image unless you were more than two stops off in exposure. Of course, you would lose some of the other images on the film if you had it specially processed. But you could ask the lab to clip the film halfway, or far enough away from those rare frames, and process the first or last half normally, to minimize such losses.

In this case, it didn't matter if the rest of the roll was lost. The bobcat image was a trophy worth the loss of the rest of that roll for this camera hunter.

One advantage of the digital acquisition of images (here with the Fuji S2) is that you can immediately check difficult exposures, such as these two black bear cubs with a brightly lit forest background.

10. auto or manual focus

• Do pros use autofocus?
• Which camera manufacturer has the best autofocus sytem?

Not all that many years ago, most serious nature photographers shunned autofocus 35mm cameras. Some still do. But anyone who seeks to capture a variety of wildlife on film today should pay attention to the advances in the autofocus cameras offered by several manufacturers.

They should also consider getting a second mortgage on the homestead! It's not enough to just get a camera body—you also need a good autofocus telephoto lens to get the full benefit of a good autofocus camera. The old adage "you get what you pay for" surely applies to camera equipment.

As described in chapter 4, you can get by with less than the best. But a serious wildlife photographer should consider shooting with the best autofocus camera bodies. Why? Because a wide variety of species present a challenge for those attempting to

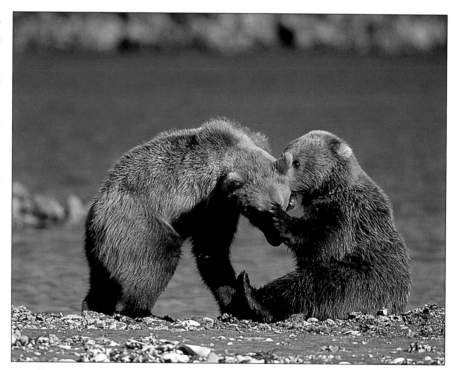

An effective autofocus camera on which the focus point can be set off center permitted a balanced composition while following the fast action of these two brown bears sparring on a beach in Katmai, Alaska.

manually focus for telling shots. The list includes ducks and geese, songbirds and herons, river otter and beaver, pine marten and fox, coyote, and perhaps even a rare cougar or wolf.

LEFT—Having a good auto-focus camera can make the difference when a rare photo opportunity presents itself, such as when this wild wolf stepped out of the bush in Denali National Park. BELOW—Predictive autofocus and rapid frame advance captured a whole set of publishable images when this bison herd charged toward the road in Yellowstone National Park.

Show of hands: who wants the best chance at getting a sharply focused photograph if they ever encounter a wolf or a cougar in the wild? And try bagging a bald eagle flying toward the camera or a loon as it surfaces with a fish or a tern zooming along overhead, and you soon learn that the benefits of a good autofocus system are definitely species specific.

Still unconvinced? Remember how my number of keepers went up with my progression to quality autofocus and rapid frame advance camera bodies?

Maybe a discussion of the evolution of autofocus cameras will help. Minolta started the autofocus offerings in the late 1970s. Other camera manufacturers began to follow suit.

The initial offerings were lower-priced models for the average consumer. That was partly because the technology wasn't very good. Early autofocus cameras worked slowly and required placing the subject dead-center in the frame. But that was okay. Most people just want to take good pictures without a hassle. And like the rest of the camera-does-everything gadgetry, autofocus improved the product for amateur users. Camera design and marketing aimed at rank amateurs is not exactly new. Years ago, Kodak promoted its Brownie cameras and film by telling folks: "You push the button, we do the rest."

Professional sports, wildlife, and other serious photographers of action showed minimal interest in the early autofocus systems. Why?

Sometimes you don't need autofocus. Behavior shots such as this image of a complacent cow moose eating leaves make interesting photographs.

First, they didn't like the center-only focusing. More artistically designed photographs often place the subject off center in the frame. They also found the slow response inadequate for focusing on fast-moving subjects.

Gradual improvements evolved with successive models. Competition among the manufacturers finally caught up to the professional user in the mid 1980s. That's when Canon made a serious change in its pro camera offerings.

And for the first time, Nikon put an autofocus system into one of its professional camera bodies, the F4. The F4 system is adequate for some subjects. Having owned a Nikon 8008 camera, an amateur version using the same autofocus system as the F4, I can honestly say that it's a

dog compared to the Canon EOS series.

Because of that, a lot of pro Nikon shooters switched to Canon in the 1980s. I was ready to switch after shooting alongside a friend who was clicking away with a Canon while my Nikon 8008 ground away trying to lock on as a grizzly approached—not the time that you want your autofocus to fail you!

And then in the mid 1990s, Nikon came up with one better: the N90S. That camera rivaled—and perhaps beat—anything Canon had for an autofocus camera at the time.

And then Nikon jumped out ahead just a couple of years later with the F5 body, at the time the fastest autofocus camera on the planet. It may still be. It can follow a target

across the field of view, predicting where it's going and maintaining focus exactly while shooting up to eight frames per second!

But Canon came back again. The Canon EOS 3 pro model not only has forty-five focus points, you can also set it to focus where the photographer's eye looks! Eye-controlled autofocus! What will they give us next?

You can get lower-priced Canon and Nikon bodies that don't have as effective a focusing system as their pro flagship models. When combined with the right autofocus lens, any of these cameras would still make a great tool for the camera hunter.

Is it all just Canon or Nikon? No. But those two manufacturers seem to have attracted most of the serious nature photographers due to their autofocus offerings.

But do you really need an autofocus camera to shoot well? Not all the time. Some critters simply don't require autofocus to make a good image—most of the time. Moose come readily to mind. It simply doesn't require the luxury of a modern autofocus camera to bag most complacent moose on film.

And then there's the whitetail. Anyone who really knows this species understands how a photographer can manually focus for great images when a whitetail freezes.

In fact, some people make the mistake of never turning the autofocus off. That's right; go to manual focus and stop using the fancy stuff you paid all that extra money for. Why would you ever want to do

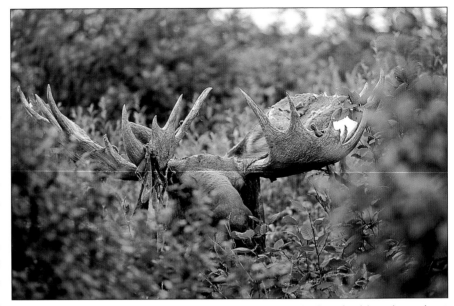

Getting a sharp image of the eyes of this bull moose, which is shedding the "velvet" that nourished its antler growth, could be difficult with most autofocus cameras, as they probably want to focus on the brighter vegetation in front of the bull's eyes.

that? Because sometimes the camera will search for the correct focus while you miss a lot of shots. Even the best autofocus cameras want to focus on the nearest or brightest objects in the area of the focus point.

An animal peering out from behind branches or grass makes one good example. A dark-feathered bird flying in front of a snow-covered mountain makes another one. Focusing on branches in front of a hiding animal usually results in an out-of-focus animal due to the limited depth of field of a telephoto lens. Focusing on a distant mountain is a more obvious problem.

The other reason you might want to shut the autofocus off is to make a more artistic composition of the subject than the placement of the autofocus point permits. Even with the most advanced camera systems, limitations occasionally exist as to how you can frame a wildlife subject in a

scene with autofocus. One way to overcome that deficiency is to focus without firing, keep the button pushed partway down, and recompose. If your wildlife subject is that willing, it's sometimes easier—and faster—to shut off the autofocus and simply manually focus while framing the final composition.

But when the action really starts, nothing beats a great autofocus capability for consistent results at wildlife photography.

11. an eye for an eye

• Why is it important to focus on the eyes of an animal?

• How do you make sure that the eyes show?

"The eyes have it."

There's a photographic rule that says that when you photograph an animal that its eyes (or eye, if only one shows) are the most important part of the image. It's generally true that:

• the eyes should show
• they must be sharp.

Have you ever seen a photograph of a person whose eyes were obscured by shadow or the bright reflection off their eyeglasses? Worse, were they

showing, but were out of focus? Did you feel cheated? Did it seem that you couldn't see the person clearly? It's the same thing with an image of a wild animal—most of the time.

The eyes represent the photographic soul of a wildlife portrait.

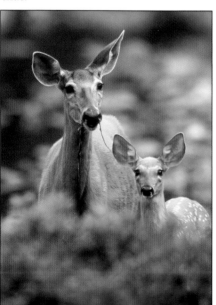 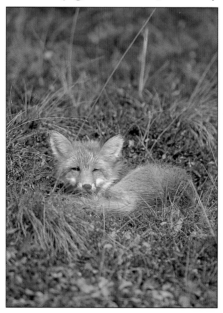 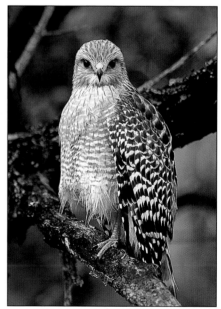

What do you see in the eyes of each of these animals? (From left to right: Whitetails in the Maine woods, a red fox in the Alaskan tundra, and a red-shouldered hawk in a Florida marsh system.)

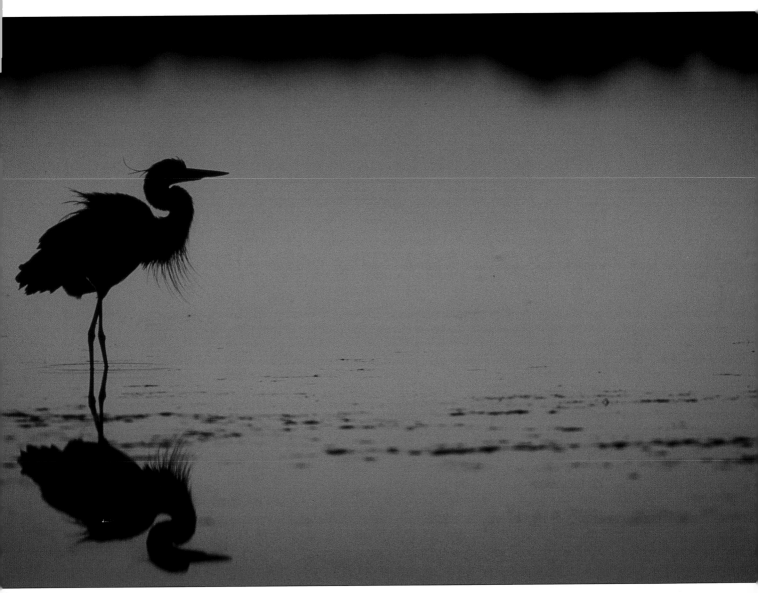

Look at the eyes in the series of animal photographs on the previous page. Do you feel as if you could make a connection with each animal's mind? At the least, doesn't it seem that you can sense something of each animal's life experience from that look in its eye? That may be why some say that images of captive animals don't show the same spark as do those of wild animals.

While that's open to debate, one thing is sure: look at animal portrait images and you are drawn to the eyes. And the ones that really work

somehow show through their eyes the essence of that animal, and perhaps, its species.

There are times when we don't need to see the eye that well—if at all—for an effective photograph. Consider animals in silhouette. Those pictures show no detail of the animal of any kind. Such images probably work because you don't get the feeling of missing that glimpse of the animal's spirit by not seeing its eyes: it's all just a shadow.

The other photographs that work even when you can't see the eyes that

When the subject is silhouetted like this great blue heron, seeing its eyes no longer matters.

well are the scenic wildlife shots. Such images probably work because we're seeing the "big picture." The composition includes so much more to look at that we don't feel cheated by that lack of intensity of the experience with the animals.

Some species present unique problems when you do try to capture that intensity on film. While we don't have to worry about glare off

of glasses in our wildlife photography, we do need to consider some other things.

For example, on a blue-sky day with overhead light, the shadow cast by the antlers of a bull moose typically covers his eyes. That's a bigger problem than you might think until you look at rolls of film where the eyes disappear into inky blackness. Moose antlers, whether in velvet—the blood-vessel laden tissue that covers them while they grow through spring and summer—or the hardened bone of the fall, present a serious problem for getting the eye right.

You can solve that problem by catching him:

- with the low sun angle of early morning or late afternoon light
- on an overcast day
- in the shade.

You could also use fill flash, assuming it would reach the moose.

LEFT—The larger landscape of a scenic wildlife image offsets the fact that we can't see the moose's eye all that well. RIGHT—Watch out for animals, like this bull moose, whose antlers cast a shadow over their eyes when in bright sunlight. While your eyes can see his, film often cannot.

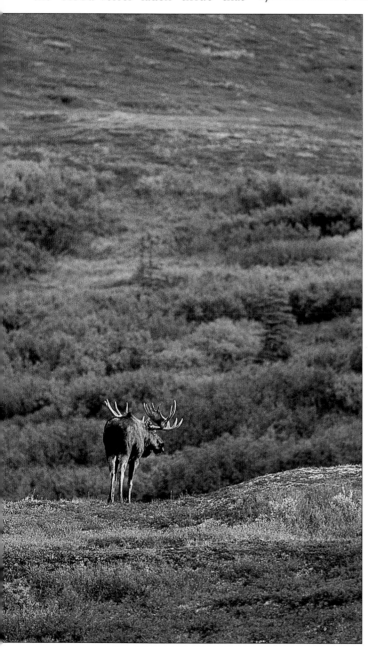

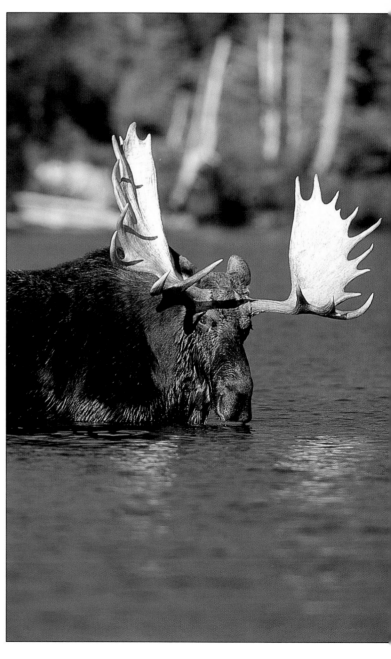

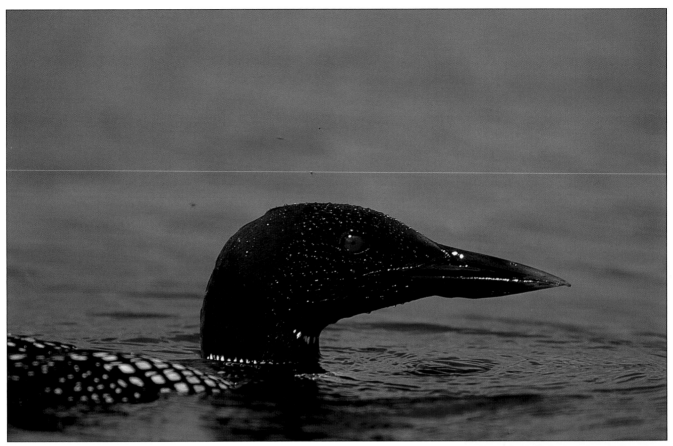

ABOVE—Catch a common loon in early morning or late afternoon light that illuminates its dark red eye to create separation from its black head. LEFT—Nothing beats the look of great natural light on a wild animal for The Mooseman.

That's less preferable for logistical reasons alone. More about that in a moment.

A number of bird species present a similar but different problem. These birds have black eyes set in an all-black head. They include the black-capped chickadee, the crow, the raven, the razorbill auk—the list goes on and on. The problem here: how do you capture the eye to distinguish it from the head? And while its eyes are red, the adult common loon in breeding plumage challenges the photographer as well. Unless you catch that eye in the light, it disappears into the all-black head of the loon.

The answer for any of these birds lies in making photographs with either a low angle sun early or late in the day, or when the bird tips its head into the light.

Some photographers throw an artificial catchlight into the eye of their wildlife subjects with fill flash. They adjust their flash unit to add only a little extra light on the subject's face. This usually requires the use of a flash extender device to match more closely the distance the light has to travel. Otherwise, the flash stops at about thirty or forty feet. With a subject 100 feet away, no light from the flash will hit it, let alone reflect back to the film.

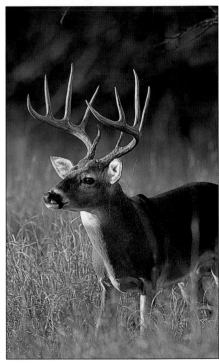

The renowned bird photographer Artie Morris often uses the flash extender made by Better Beamer to capture intriguing images of birds.

Anyone interested in learning more should get the book: *The Art of Bird Photography: The Complete Guide to Professional Field Techniques* by Arthur Morris (AMPhoto, 1998).

Fill flash requires less light than if the flash were used as the primary light source, and so this often requires some experimentation to get the best results. The better flash units to use for fill flash are the modern "smart" flashes that read the light reflecting off the subject as it comes through the lens and automatically controls the exposure. Many nature photographers adjust their fill flash settings to shut down the flash when less than the normal fill flash amount has reached the film, perhaps as much as 1.3 times less. Again, this requires some experimentation for the best results.

While some make excellent images with fill flash, The Mooseman generally prefers to wait for the natural catchlight. Artificial lighting outdoors often seems to be just that: artificial.

But as with most things in photography, it's all in the eye of the beholder. Some top nature photographers—Frans Lanting and Nick Nichols come to mind—do great work with fill flash.

Learn to look for the catchlight in the eye of all your wildlife subjects. Notice when it's not there, and figure out ways to get it into your photographs.

Develop an eye for an eye, and you'll bring home a lot more trophies for your images.

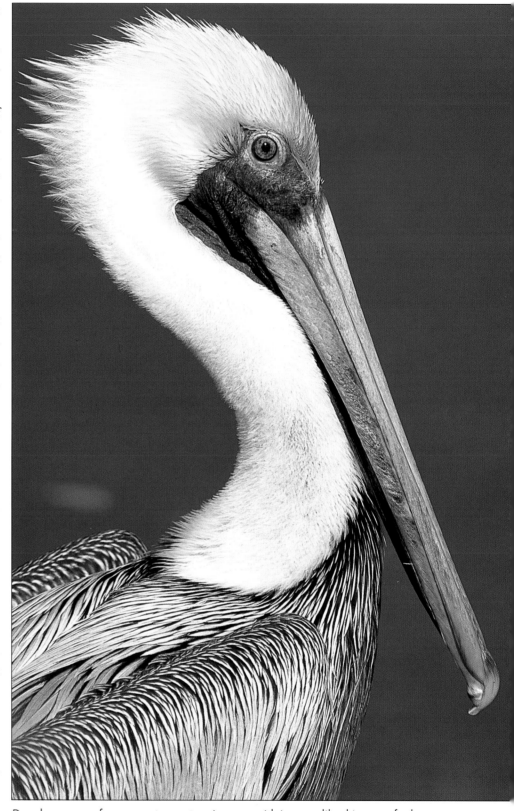

Develop an eye for an eye to capture images with impact, like this one of a brown pelican.

12. bracket the focus point

• Should you "stop down" to f16 to get everything sharp?
• How do you focus for multiple subjects?

The telephoto lenses required for wildlife photography have extremely limited depth of field—the distance in front of and behind the point at which a lens is focused. How limited? A 500 millimeter lens—a telephoto popular among wildlife photographers—when focused on an animal thirty feet away, has a depth of field of:

• seven inches when set at f8
• five inches when set at f5.6 at the same distance
• three inches when set at f4 at the same distance.

Three inches. Think about that. Since wildlife photography often requires using the fastest aperture,

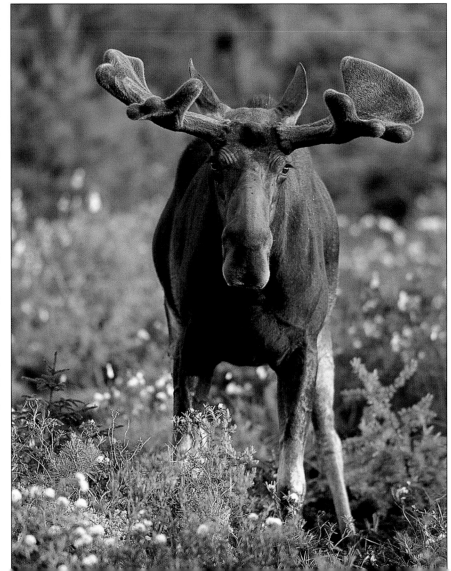

Focus carefully for a dead-on moose nose.

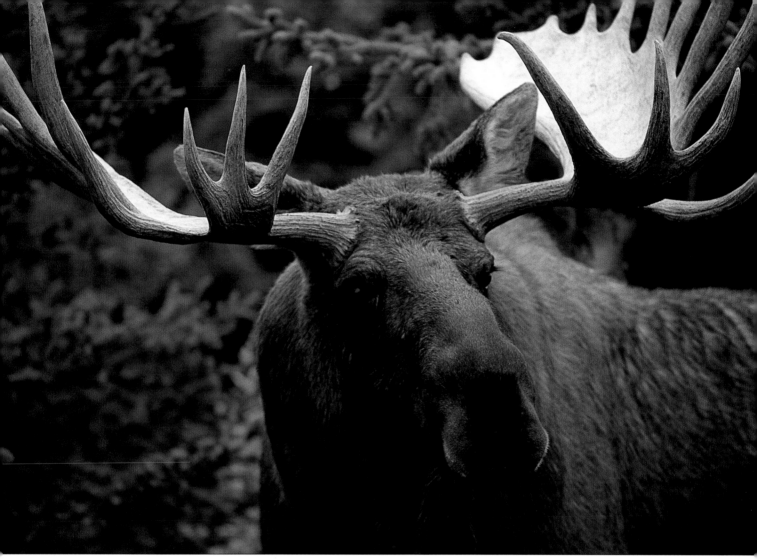

Nothing fills the frame like a big Alaskan moose!

due to the need to get enough light to the film, consider how that shallow depth of field impacts your results when shooting wide open. And you're supposed to focus on the eyes—and get them sharp! Remember how we said that an accurate and efficient autofocus helps to bring back more keepers? The limited depth of field of a telephoto lens is one reason why.

Now think about what happens if a bull moose standing stock-still thirty feet away looks right at the camera and you focus on his eyes. Do you know how long a moose nose is? The distance from the nostrils to the eyes is about eighteen inches on your average moose. That means that when shooting a moose looking straight at you from thirty feet away you cannot get both the nose and eyes sharp, even at f8. A photograph with out of focus moose nostrils can be distracting. Remember that on a moose, the nose is very large.

Depth of field gets better the farther you get from a subject. And while it's great to be thirty feet away from most wildlife, with a 500mm lens you would be too close to a bull moose to show its complete rack of antlers in the picture. So get back.

How far? At fifty feet, the depth of field for a 500mm lens becomes:

- nineteen inches at f8
- thirteen inches at f5.6
- nine inches at f4.

Now we have enough depth of field to get the nose and eyes sharp at f8. Or do we? Let's assume that when you focus on the moose's eyes the depth of field is split—half of it falls in front of the focus point, half behind. That places the moose's nostrils about nine inches in front of the closest edge of the acceptably sharp part of our picture.

Since most sources state that depth of field generally falls only one-third in front of the focusing point, and two-thirds behind it, your problem is actually worse.

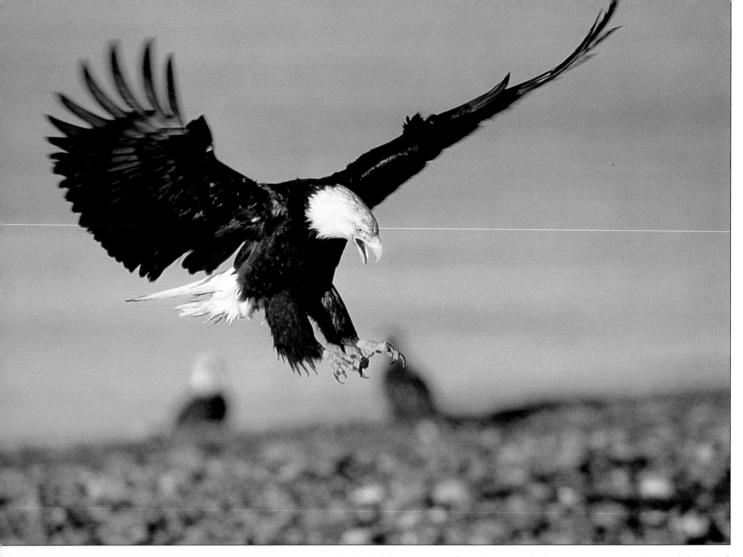

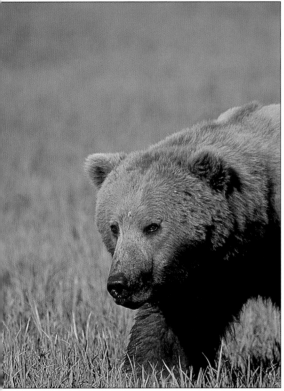

ABOVE—A slight blur in parts of a photograph show motion. LEFT—Limited depth of field can make an animal really pop out of the background.

There are ways to improve your odds of getting that picture with both the nose and eyes sharp. The trick is to focus on a point forward of the moose's eyes. With nineteen inches of depth of field to play with, you might even bracket a few shots, assuming you have the time. Unlike when bracketing exposures and getting some over- or underexposed, you're not going to toss any images by bracketing the focus point unless you focus so far forward that you drop the eyes out of focus.

But a safer way is to back up even more. At 100 feet, the depth of field gets a lot better:

- six feet, three inches at f8
- four feet, three inches at f5.6
- two feet, eight inches at f4.

But can you get a frame-filling portrait of a bull moose at 100 feet, even with a 500mm lens? Almost. At that distance a subject 7.4 feet long fills a 35mm film frame in the longest dimension. Some mature bull moose have racks approaching the five-foot range. An Alaskan moose grew a record rack with an eighty-one-inch spread. You could just get him in your picture looking at the camera dead-on at 100 feet with a 500mm lens.

Next, consider a bald eagle flying by parallel to the camera at 100 feet. With a 500mm lens set at f4, those two feet, eight inches of depth of field should be enough to get it all sharp, right? Wrong. The wingspan of a bald eagle approaches seven feet. Take half of that, and you're at three-and-a-half feet. If you focus on its eye, the wingtip will be out of focus.

So should you think about bracketing the focus point for the eagle? I sure wouldn't. It's tough enough to lock on to a flying bird with even the best autofocus systems, let alone mess with the focus point. Shoot for the eyes, and don't worry about the blurred wings. And you know what?

You'll probably like the picture anyway if the eyes are sharp. Sometimes you don't want to have the whole animal in focus. Blurring the wing shows motion. Some people even consider it more artistic.

It's worth noting that no matter what aperture you stop any long telephoto lens down to, you're still not going to get much depth of field. Some folks seem to think that if they stop way down they can get great depth from a telephoto lens. While that's true with a wide angle, and even a moderate length lens, it's physically impossible with any long telephoto lens. See *Photographic Lenses* (Ernst Wildi; Amherst Media

2002) if you want to know more about how this works.

But trust me that you're pretty much wasting exposure capability if you go past f8 for most long telephoto shots. Consider that a 500mm lens at f22 only has eight feet, three inches of depth of field when focused on a subject that is 100 feet distant. Focused at thirty feet, it provides a scant eighteen inches of depth of field.

Have you been wondering how I know these numbers? I checked the depth of field tables in the manual that came with my lens. Remember what I said about reading your camera manual? That goes for the manuals that come with your lenses, too. Your odds of consistent results at wildlife photography improve greatly if you really know what your equipment can—and cannot—do.

The focus here is the male loon yodeling at a floatplane intruding the airspace over his lake. The pair of loons and his response tell a story. While it might have been better to avoid the closer female loon altogether, sometimes you take what you can get; this image could be cropped for publication.

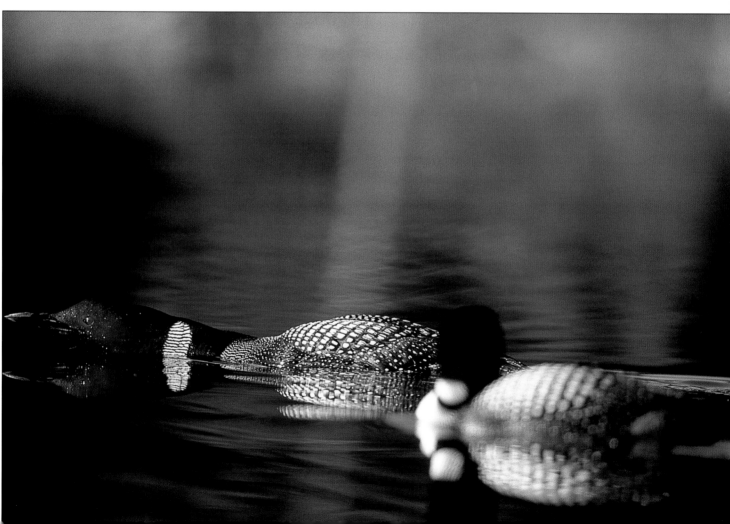

The closer you get to an animal, the more limited the depth of field you will get from a telephoto lens. The side profile on this egret and lizard helps keep most of the image in focus.

The limited depth of field of a telephoto lens does have one advantage. It typically "pops" a subject out of a photograph. That makes for a dramatic composition, as the animal breaks out of the background.

But if you have multiple subjects, watch out. Focus on the one closest to the camera unless you have a special reason not to. Why? Because an out-of-focus animal in the foreground of a photograph typically sticks out, and that generally ruins the image.

There's another aspect to telephoto lenses that you should be aware of: minimum focusing distance. All lenses have a minimum distance to the subject at which you can focus them. And since the reproduction of the subject size in the photograph gets bigger the closer you get, the lens's minimum focusing distance can affect your work significantly, depending on the actual size of your subject.

Some photographers who work with small birds use extension tubes to increase the minimum focusing distance. These simple tools have no glass and make the lens longer without adding any real magnification. But because they permit you to move a bit closer to the subject, based on the length of the extension tube, you get a larger size image of the subject on the film frame. You also lose light. Use both good tripod and camera shake control techniques to offset that problem.

You can also gain image reproduction size by adding a teleconverter to the prime telephoto lens. A 500mm lens turns into a 700mm lens with a 1.4 teleconverter attached to it. That improved magnification results in a somewhat larger subject reproduction size while staying at the same minimum focusing distance of the lens without the teleconverter.

And what is the minimum focusing distance of that lens? The manual says it's 16.4 feet. You're probably wondering why that would ever be a problem—you can't get that close to wild animals, can you? If you use the techniques described in the next chapter, you sometimes can. But if you do, you had better be good with the focus point. A 500mm lens focused at 16.4 feet and set at an aperture of f4 has a depth of field of exactly one inch.

13. know when to be where to shoot what

• How do you find baby moose to photograph?
• What about rutting whitetails?

"F8 and be there" described the efforts of Robert Capa, the famed photographer who consistently got great pictures of the major wars of the mid-20th century, until he stepped on a land mine in Indochina in 1954. While wildlife photography is a lot less hazardous than covering a war on film, you still need to plan to really be there to succeed.

The best planning is done well in advance. Your plan will depend on the priorities for your time in the seasons ahead. It will also depend upon how much you know about each of the species you've decided to target.

Not the least of the reasons to plan ahead is so that you won't interfere unduly in the lives of your intended subjects. While there are varied opinions about what constitutes harassment of wildlife, you'll obviously get the best opportunities to photograph animals that hang around. And if you ever try to sell your work, you'll soon learn that most pictures of the east end of a critter headed west do not excite photo editors.

Another reason to plan for your intended subjects is so that you will target the right places. To maximize the results of "being there," you need to plan when to be where to shoot what.

North America offers so many choices for the wildlife photographer that the plan often requires considering what to pass up on for the year. Seriously: we've got moose and deer, black bears and bobcats, foxes and coyotes, bald eagles and osprey, shorebirds and seabirds, nesting loons and songbirds, seals and whales, upland game birds and a variety of waterfowl—and that's just for starters. You could try to go after all of it, but you'd soon discover that you need to spend a lot of "time on point" to bring back better images of any given species. And because some wildlife shooting seasons overlap, there simply aren't enough days to do it all.

Let's say that part of your plan for this year is to photograph infant moose. You will know from your research that moose are born from mid to late May all across their range in North America. You will also know that their mothers typically hunker down near the birth site for a couple of weeks. They start to bring them to face the world when they're able to run well enough to evade most predators, in early June.

You also know that moose like to feed at ponds in spring and summer. And you've learned that mother moose are defenders who will not tolerate a close approach from a human, especially in the deep woods.

Knowing all these things enables you to determine that your best chance to photograph a moose calf without harassing your subjects or getting yourself stomped is probably going to be from across a pond in June. So the first thing to consider is where in moose country you will find "workable" ponds.

A variety of sources for such information exist:

- Internet search engines
- books on moose
- photography magazines
- fish/wildlife management agencies
- tourism bureaus
- other photographers.

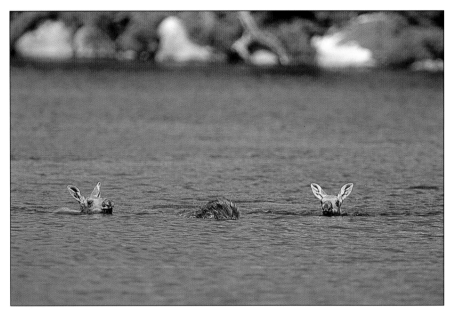

TOP—Moose mothers typically bring their young calves with them while they feed in ponds once they are a couple of weeks old. BOTTOM—White-tailed deer mothers instruct their young fawns to hide and stay put until they are strong enough to outrun a predator.

But say that you want to target whitetail fawns at the same time. You can't do it. Why not? Because whitetails are hiders. Deer mothers don't often bring their babies out at that age when they go to a moose pond to feed along the edge or to drink. So you have to look someplace else—not to mention do a whole different set of research—to find infant fawns. The ultimate answer: target places more suitable for deer.

Or say you're also targeting black bears. North America's black bears number around 500,000. That's a lot of bears! And while they often sneak through the same woods as moose, they don't show themselves much. They're certainly not likely to pose at a moose pond with people hanging around it.

That's not to say that you might not spot a bear at a moose pond. In fact, one of my greatest hopes is to be there when a black bear tries to take down a moose calf. Can you imagine the images you might make of mother moose chasing it away?

But you've got a better chance if you plan to camera hunt black bears at places where they are more likely to hang out. And since black bears are so elusive—a bear researcher I know says that they "ghost through the woods"—you have a much better chance of finding black bears if you target them when and where their food source is more limited. The green-up of vegetation in early June makes one good time to look for black bears—in the right places.

See how this is working out? While you might encounter a moose

calf, deer fawn, or black bear anywhere in their range, the likelihood of doing significant photography with all of them at the same place at the same time is slim. And so you have to make choices as you plan. Then, scout your place for signs of the target species until you find the best possible place to wait. Then stick it out on point until you get what you need.

■ FOOD IS A KEY

Not the least of the things that you should think about as you develop your plan to work with any given species are what, where, and when they eat. Why? If you were an alien from space who came to Earth to photograph humans, what would be one of the best ways to find them? Go to a fast food restaurant at noon, right?

Let's consider white-tailed deer again. What do deer eat? It depends upon where they live and what the season is. Whitetails in different parts of North America have different food preferences. Some favorite deer foods include acorns, apples, clover, corn, grasses, forbs, and a wide variety of browse foods—the tender twig ends, buds, and leaves of shrubs and trees. Since browse species vary so widely with geography, you may need to consider many things as possible foods for deer, even ornamental shrubs. I once photographed a Texas whitetail eating a prickly pear cactus; his Maine cousins would walk right past that!

Look for deer food sources when you scout the area where you plan to

LEFT—This Texas whitetail sampled the prickly pear cactus, a strange deer food indeed! BELOW—Looking for deer foods requires that you know something about what they do eat. BOTTOM—Browsed twig ends shows that wild animals have been feeding in an area, but what species? This munching was done over seven feet high, too high for a deer, but a sure sign of moose.

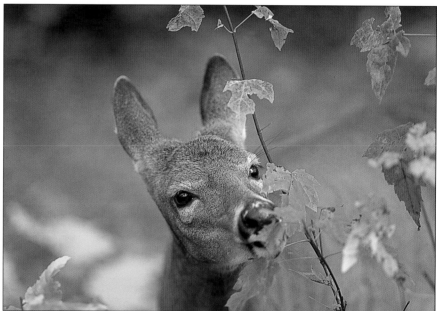

camera hunt. Also look for other signs of deer, including nipped branch ends from feeding, as well as pellet piles and bedding sites, and of course, tracks.

■ SEX IS A KEY

It's no accident that many state fish and game agencies schedule their big game ungulate hunting seasons during the mating season of the target species—moose hunting in September or October, deer hunting in November, and so on. That's partly because the males of the species sport their best-looking antlers during the fall rut, or mating season.

It's also because the sex drive of many of these animals overpowers their fear of humans during the rut.

This is particularly true for moose. While the most mature white-tailed bucks remain wary, the younger ones go crazy during the deer rut. They cruise the woods making and checking scrapes—patches of earth that they scrape bare with their hoofs and urinate in to scent-mark. They also mark their territory with an overhead branch that they lick or rub against a gland near their eyes. Bull elk "bugle" to gather and control their harem of cow elk.

Let's consider moose again as an example for a photography target during the fall. The bulls wander through their home turf, grunting to attract a mate, perhaps thrashing antlers against the bushes, and in so doing they often give away their position. The cows also make a call when they are ready to mate, a loud and long moaning sound.

Moose are also vulnerable to being "called in" during the rut.

Bull moose thrash the bushes to blow off steam, practice their antler technique and alert nearby females during the moose rut.

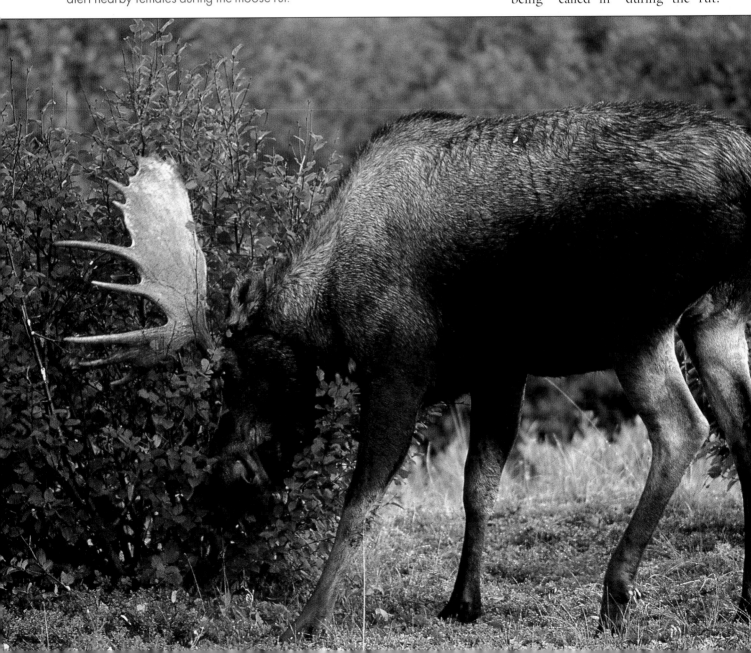

While it's not permitted in national and some other parks, moose-calling with a voice call can be most effective. Where it is permitted, simulating the wail—"weeaahhhoowww"—that cow moose use to signal to bulls that they are in estrus can really attract the attention of an amorous bull moose. If you plan to make this call, do it only when you have a really good climbable tree handy!

All of this activity makes for dramatic photographs if you can find a bull moose to work with. And that would seem to be easier to do during the rut. Actually, the reverse applies, depending on which moose you're after. The moose of the open tundra and minimally treed taiga of Denali National Park in Alaska show themselves quite often during the days leading up to and during the rut.

But the ones in the northern forests of Maine, New Hampshire, and Vermont live in thick cover that not only makes it hard to see them, but often presents greater danger to try to get near one if you see it or hear it beating the bushes out there somewhere.

What's The Mooseman's secret for photographing bull moose in the fall in New England? Know your species. Then you'll know not only when to be where to find one, but how to approach it when you do.

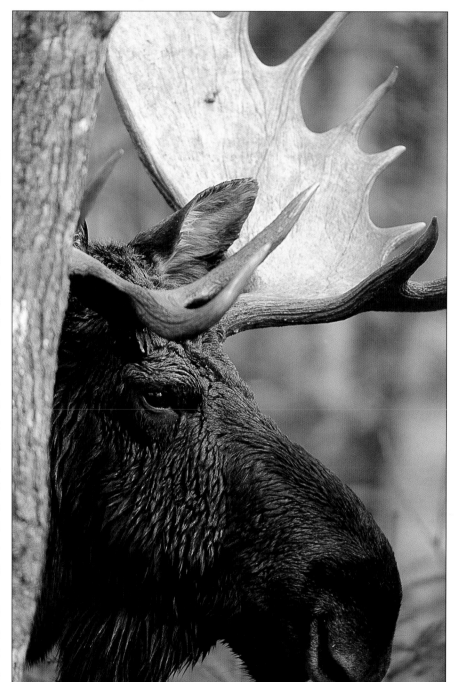

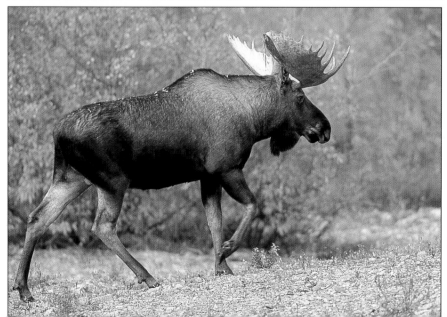

14. *approach techniques*

- How do you get close enough to get good photographs without interfering with wildlife?
- Do you have to hide from every animal?

As with most pursuits, getting a great photograph of a wild animal often comes down to how you approach it—pun intended. But getting closer isn't often so easy to do.

The Mooseman's sixth rule of wildlife photography says to take the shot you've got before you try to get closer. Once that's in the can, then try to improve on your opportunity by moving in. Some techniques that can help you to get closer include:

- "still" hunting
- stealth approach
- open approach
- mobile blind approach
- animal impersonation approach.

■ STILL HUNTING

Still hunting means just that: you are *still* hunting—walking slowly through the woods in search of an animal. Still hunters take a few steps at a time and then stop, look, and listen.

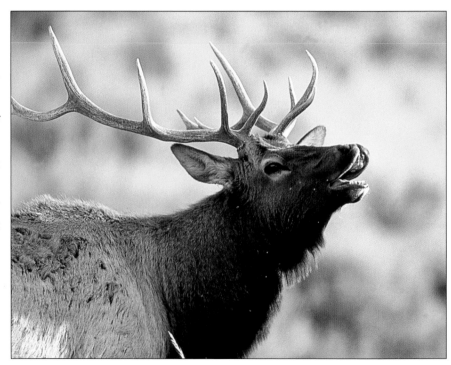

Listen for animal sounds like the bugling of a rutting bull elk when you're searching for wildlife subjects.

Listening helps when looking for wildlife to begin with. It helps to locate places where you might want

to wait a few minutes, or perhaps even hike in a ways to find an animal. Lets say that you're cruising the road at the northeast side of Yellowstone National Park looking for elk in the fall. Stop the vehicle, shut off the engine, open the window—better yet, get out—and listen for the bugle call of a bull elk.

To still hunt successfully, you must learn how to walk quietly by avoiding twigs that snap, leaves that crackle, and acorns that pop. Remember that you want to listen to the animals in the woods, not have them hear you. The most effective still hunters learn to walk by placing the ball of their foot down first on hard terrain, where the normal human footstep—starting with the heel first—often makes a sound as the toes slap the ground.

Wearing camouflage, or at least clothing that blends with the environment that you're working in, makes sense for still hunters. If you work an area that's open to hunting, be sure to note when those seasons run. While it's generally not productive to pursue wildlife photography in such places during hunting season to begin with, if you choose to, wear blaze orange if the hunters do.

■ STEALTH APPROACH

Unlike the still hunter who's looking for something to photograph, the wildlife photographer in stealth approach already has a target for the camera. He or she spots a deer, bear, or bird in the distance and then tries to get close enough for a good photograph.

It helps to blend with the natural environment, whether you're still hunting, using a stealth approach, or setting up an "ambush" when you're after wild animals that flee at the discovery of humans.

How? In the stealth approach, you make use of available cover. Available cover often isn't all that apparent. While a nearby tree or large boulder presents an obvious way to hide from an unsuspecting animal, a slight gully or a modest ridge might not.

Sometimes you need to crouch to make use of such available cover. You might have to crawl to keep below a low ridgeline. And sometimes you need to make a distant tree work by placing yourself in line with it so that it blocks the animal's view of you as you approach the tree.

You'll not often enjoy a simple straight-line approach. But many times you can put several natural elements that offer cover together to make a successful zigzag approach. Learn to look at the terrain that you want to cross for any type of cover.

As with the still hunting method, it helps to blend with the environ-ment. Camouflage or drab-colored clothing stands out less, depending on the background.

No matter what you're wearing, always avoid silhouetting yourself against the sky, water, or a bright yellow field.

The photographer in stealth approach also has to watch out for making noise, and should be aware that his or her scent could carry toward the unsuspecting animal. If your subject is a great blue heron, don't worry about scent. If it's a whitetail, worry. Your methods for a stealth approach will depend upon the species.

Wild animals of any of the prey species don't allow anything to sneak up on them easily. Think about this: if your mother taught you from your first day on the planet that throughout your whole life you had to worry about being eaten by some-

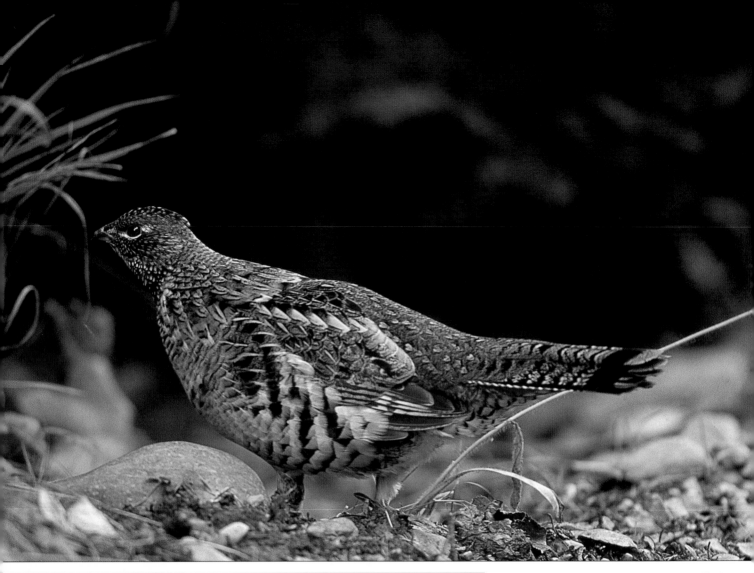

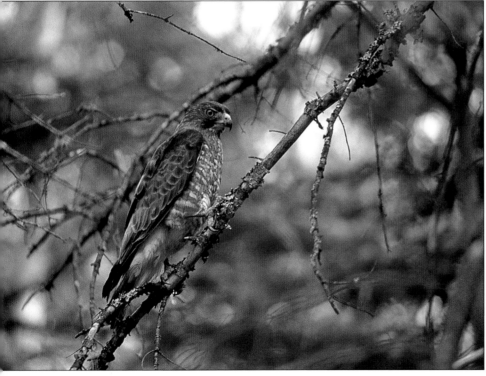

ABOVE—Prey species, such as a ruffed grouse, don't allow much to sneak up on them. LEFT—Predator species also get nervous if you come too close, and especially if they lose sight of you.

thing that would try to sneak up on you, would you be easy to get close to for a photograph?

Predator species present a different problem. They know intimately all the tricks that you want to use to get close. After all, that's how they make their living. If they don't see you when you first spot them, they're typically not concerned about those techniques being used on them. But if they did see you, it's often a waste of time trying to get close by a stealth approach. As soon as they lose sight of you, they leave; they know what you're thinking.

■ OPEN APPROACH

This brings us to the open approach. With the open approach, you simply walk toward the distant animal. It helps to make your approach slowly. It also helps if the animal has little or no fear of humans.

If it has any fear, this approach only works if you take it real slow and stop and wait a few minutes before moving closer. Take ten feet at a time, even less if need be. Watching the animal should guide you as to how much to try at a time.

Avoid a direct approach. Go sideways to the animal and move forward a few feet as you do. Zigzag toward it with an indirect approach, and stop when it looks up at you. Try pretending that you're not interested

Wild animals have a different view of being "cornered" than humans do. This brown bear stood up to get a better view of what might be blocking its preferred escape route.

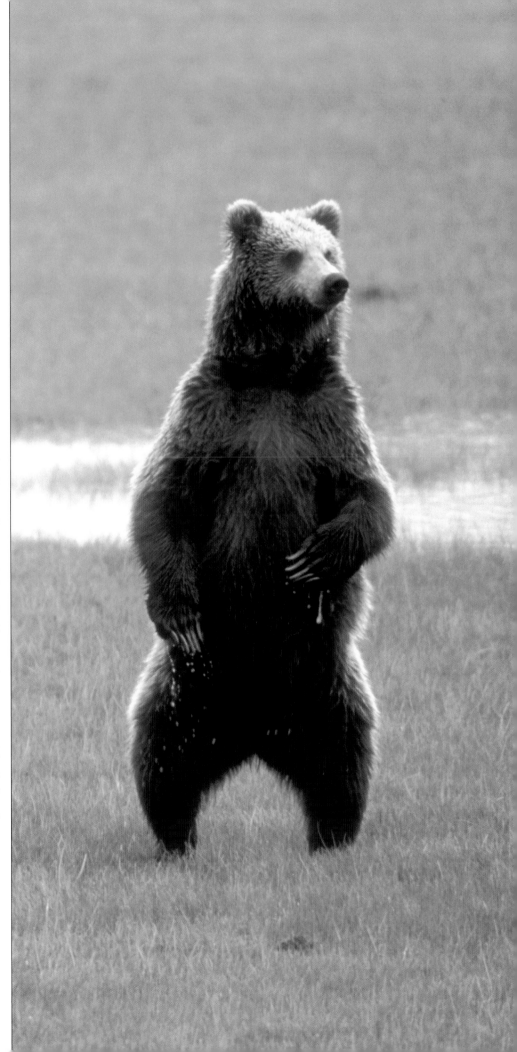

in it. Turn your back to it, if it's safe to do so. Look up at the sky. Fiddle with your lens. Play at photographing something else out there. Pretend that you dropped something in the field. Once the animal relaxes, take another ten feet on it. And then take another ten feet.

It's not that easy to get all that close to most wildlife with an open approach unless you really work at it and are patient. Again, think about how you would feel if someone you didn't know came walking toward you with a gleam in their eyes.

Also think about the fact that an animal often has a whole different perception of the feeling of being "cornered" than you do. Look for the exit paths to the closest cover that an animal has as you approach—because it surely will. And understand that some animals want to leave the same way that they came. If you block that path, they might feel cornered even when they have an open field behind them—perhaps especially when they have an open field behind them!

If you're with a group of people, or even just two, approach from the same side. Don't spread out, or worse, surround the animal. Again, how would you feel?

■ MOBILE BLIND APPROACH

With this technique, you drive a vehicle, paddle a canoe, or motor a boat toward the animal you hope to get closer to. The vehicle or watercraft serves as a "blind." While the two-legged profile of man causes alarm in the minds of many wild animals, some don't see such inanimate objects as a threat connected with a human.

You usually need to shoot from the moving blind as well. Driving up and jumping out doesn't work if you really had to use the vehicle or watercraft as a moving blind for your approach to begin with. So be ready to shoot before you get there. We'll look at how to do that in a later chapter.

If at all possible, use an indirect approach; avoid flashing a paddle or making waves with a boat motor that surges toward your subject.

Practice at paddling without making a lot of motion. An electric outboard motor of the type fishing enthusiasts use for trolling makes a great way to cruise up slowly, silently, and wake-free without unduly alarming wildlife.

Set a steady, slow approach that doesn't suggest that you're trying to sneak up on the subject. Ease up slowly as you get close enough to shoot. Driving up and jamming on the brakes or having to back paddle a canoe doesn't inspire confidence in most animals.

Neither does creeping up in a vehicle at places where wildlife is used to seeing cars and trucks go past at faster speeds. With a watercraft, slower often works better because animals have watched slow trolling fishing boats. Again, think about how you would react to a too-slowly moving vehicle coming toward you. What would make you the most nervous about its intentions?

This approach can work in places where the animal is less concerned because it senses that it is safe. But any animal that has been subject to much hunting pressure will be nervous about any oncoming vehicle or craft. An example is waterfowl, especially in the fall. Why the fall? Because they've been hearing guns going off. Such birds will probably

The prettier they are, the harder it can be to get close to them once hunting season starts. Here, a wood duck drake.

I called this moose out from the woods with a female moose mating call, then grunted to him in his own language to encourage him to pose for a minute.

not permit you to get into camera range.

But a photographer in motion might slowly float up on unsuspecting ducks or geese in a naturally camouflaged floating inner tube blind, or better yet, a more stable duck hunter's floating blind. Photographers who use inner tube blinds usually wear waders and walk slowly along the bottom of shallow stretches. If they venture out into deeper waters, they paddle with their feet, or even with skin-diving flippers.

■ ANIMAL IMPERSONATION
This technique involves making yourself resemble a wild animal that a subject species feels comfortable at having in close proximity. Native

American hunters used such ruses, and today, wildlife researchers probably use this technique more than wildlife photographers. Some moose biologists have worn "antlers" or carried them at head level, and some have worn a complete fake head of a moose to study the reaction of a bull moose during the rutting season. Unless you really know your moose and are good at reading their body language, I'd think twice before trying it!

But wildlife photographers can pretend to be an animal without provoking a charge from a threatened rival. One way is to make the sounds

of an animal. This often works if your subject can't see you all that well, or if it has poor vision—as a moose does.

It also can work if the animal sees you but is somewhat comfortable with your presence already. I regularly "talk" to moose in their own language where it's legal to do so—note that in many federal parks and refuges it's not—to make them feel more at ease as I approach. That's part of why they call me The Moose-man. Whether my subjects actually take me for a moose is debatable, but my calls seems to calm them. Just be aware of what you're saying to a

moose or any other animal you try "talking" to!

Canadian outfitter and guide "Tundra" Tom Faess devised a ruse to approach caribou in the open tundra of the Northwest Territories. Two people stand near each other and the front person raises their arms above their head and slowly rocks their torso back and forth to simulate a caribou with a large rack of antlers as it feeds. They then approach slowly. With some practice, and depending on the caribou, this can get you into decent camera range.

Which of these techniques is the best one? It really depends upon the species and the life experience of any given animal that you want to approach.

Animals that live where wildlife is heavily hunted or somehow harassed by humans generally won't permit you to get closer. Still hunting, a stealth approach, the use of mobile blinds, and perhaps animal impersonation work best for such animals.

Strangely enough, animals that live in areas where they feel safe with people often spook if you do try to hide from them. They wonder why you're trying to sneak up on them. Wouldn't you? But they will tolerate an open approach to within a reasonable distance. What's a reasonable distance? That will depend on the species and the individual animal's experience with people.

No matter where an animal lives, each one has what is often referred to as a "fight or flight" distance. Fight or flight actually refers to how the animal will respond to an intruder in its "personal space." Get too close to a mother moose and she might well come after you with her front hooves raised! Or she could leave, dragging her calf in tow in a huff. But what's too close? Only the moose knows for sure.

The key is to watch the animal carefully as you approach. Learn the species' body language so that you understand how it is responding to your approach.

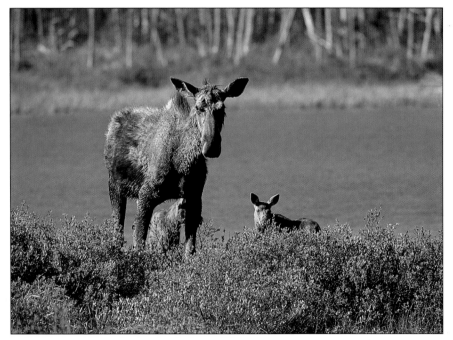

TOP—Pretending to be another animal can sometimes get you into a decent camera position on a curious species like the caribou of the Northwest Territories. BOTTOM—A wary moose mother looks for a safe exit from the pond. Pay attention to an animal's body language while you're photographing.

A wary bull moose looks out from behind protective cover.

As with all wildlife photography endeavors, the more that you know about a species, the better your chances to get real trophy images will be. Let's consider how a moose photographer profits by learning some biology.

Most moose living in protected areas—not hunted—show little fear of humans. After all, they're moose—one of the largest land mammals of North America. But to capture a wary bull moose on film, you really need to work at it.

You can do it if the big guy can't smell you, hear you, or see you. Moose have a keen sense of smell and great hearing, but they don't see very well. They can't discern a person who blends with the woods at a hundred feet or so who isn't in motion.

Only one of those three variables is easy for you to control: stay hidden. The scent part needs more work. If the wind—even a light breeze—blows past you toward the moose, he will detect you. Count on it. And if you make any noise at all, he will hear you. Moose have an extremely keen sense of hearing. Sound carries with the wind as well as scent. And so the photographer who pays the most attention to the wind direction scores the most wary moose.

Or how about waterfowl? The best approach technique for wary waterfowl probably comes from a different page of the duck hunter's book: show up before the birds do and hide. I've ambushed plenty of wary waterfowl by setting up in the dark before the birds got close using the simple camouflage cloth blind described in the next chapter.

15. *blind moments*

- How long does a blind have to be in place before wildlife will accept it?
- What's the best type of blind to use?

The early practitioners of wildlife photography soon discovered that when they hid from their subjects they often enjoyed a better chance to capture them on film. While we have many places with less wary animals where hiding isn't required, wildlife photographers of today can learn much from those early photographers when it is.

While George Shiras was exploring ways to sneak up on the beasts and birds of North America in the 1890s, two English brothers were experimenting with bird photography in the United Kingdom.

Richard and Cherry Kearton devised a number of ways to get close to birds. These ruses worked well enough to get the pictures for the first book ever completely illustrated with authentic photographs of wildlife, *British Birds' Nests* (Cassell & Company, 1895). They wore clothing to blend in with the environment. They used artificial tree trunks, fake rocks, and even a dummy bullock—the stretched skin of an ox drawn over a framework—for "hides." They found that a simple tent blind worked just as well. It often does today.

Arthur Dugmore, the British photographer working in North America in the early 1900s, often used natural blinds made of brush, sticks, and grasses. He also made a good point in recommending doing some "housekeeping" before getting into any blind.

Clearing a shooting lane—a path that is free of fallen twigs, weeds and the like—for the lens is often required. Ethical outdoor practices and the rules of the location should always be followed. If growing vegetation would have to be unduly disturbed, select another spot. If it's not permitted to clear any vegetation, don't.

Some places don't permit blinds. National Parks, United States Fish & Wildlife Service National Wildlife Refuges, and many state parks have rules about the use of any blinds other than ones they might provide. Even on private land, always seek landowner permission before setting up a semipermanent blind.

Wherever it is, to be useful a blind needs to do several things:

- it must effectively hide you
- it must be comfortable enough to permit staying in it for long stretches
- it must permit seeing out well enough to detect an animal as it approaches
- it must permit photography without your movements alerting the subject.

TOP LEFT—The manager of the Moosehorn National Wildlife designed and placed this semipermanent blind in cooperation with the North American Nature Photography Association. Note the many possible window openings. TOP RIGHT—Using a camouflage cloth or even simply a towel draped around the lens allows for movement inside the blind without it showing. LEFT—Atlantic puffins pose where the folks in this blind can't see them!

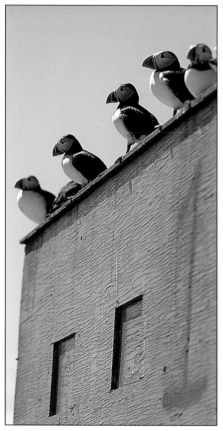

Blinds of two types can be used: semipermanent and portable ones. If the blind is semipermanent—nothing is permanent in the blind business, as nature always wins sooner or later—it also must be strong enough to withstand what the weather throws at it. That can include heavy snow loads and high winds.

If you're bringing a portable blind to each session, such strength is less of a concern unless you plan to shoot on extremely windy days, in the pouring rain, or during a blizzard.

■ SEMIPERMANENT BLINDS
The blinds made by bird researchers, while enticing due to their size and sturdy appearance, often turn out to be difficult to work from. Remember that folks using spotting scopes design these. Such blinds often have small windows, which do not easily accomodate the large diameter light-gathering end of a telephoto lens. They also often have only a few window openings and all of them usually face in one direction. It can be quite maddening to sit in one of these and to hear birds calling or chattering behind you or on the sides without windows!

For all semipermanent blinds, look for models that are designed for photography. If you build the blind, keep in mind that you'll want to be able to shoot from all sides and plan accordingly.

Another downside to fixed blinds is just that—they are in a fixed position. If the birds aren't coming close, you're not going to get many photo opportunities.

■ PORTABLE BLINDS
Portable cloth blinds work well because you can change your position easily. Their downside is that, depending on the species, a blind must be in place for a long time before some animals feel comfortable with its presence.

The Rue Ultimate Blind is a portable and easy-to-setup cloth-on-metal framework blind designed by

TOP—A camouflage cloth blind that drapes over the tripod and photographer and permits "seeing" through it can work well if the photographer sits where he or she blends in. This photographer stands out too much against the background to fool a wary species. BOTTOM—This photographer blends well but needs to take care when making any hand movements.

Leonard Lee Rue III, a famed wildlife photographer, has the advantage of water resistance and has anchor points to secure it from wind. This blind is roomy and has well planned camera ports of adequate size.

As light as the Rue blind is, you may not want to carry its extra baggage. Some prefer the simplicity of a camouflage cloth blind that they can easily carry in their camera pack.

If you can, get a cloth blind made of an almost see-through fabric. You can then watch in all directions while hidden by this cloth. The simple green and brown camouflage cloth of lightweight material found at many Army & Navy surplus stores works well. Some camouflage cloth is so thick that you cannot see out except at the eyeholes or through the lens openings. These blinds can be as restrictive as a wooden one without enough windows.

As an alternative, just wear camouflage clothing. Some of the new three-dimensional camouflage jackets and pants sold at hunting stores hide you quite well. You should wear a hood and gloves with these. A downside comes when working with animals such as eagles or whitetails, both of which have excellent vision for any motion. Under a portable blind slight hand movements generally don't show. With just camouflage clothing, every motion shows. Think about what happens when changing film.

You can tie a lightweight cloth blind around your waist and walk into the woods or across the marsh. When you get to where you want to set up an ambush, use your own head and your tripod mounted lens as supports to drape the cloth over your body and poke the lens out an opening. You can either stand with this simple cloth blind wrapped around you, or sit under it.

Sitting is more conducive to sticking around longer. But bring along a lightweight pad or inflatable seat, even a space blanket to sit on, and you'll be a lot more comfortable. Some photographers carry a light-

weight chair. In a pinch, a large plastic trash bag can take the sting out of sitting directly on the cold or wet ground.

Sitting also makes you less noticeable. Deer in particular know everything that's in their home range and will spot a new object and consider it with suspicion. To get wildlife to accept a portable blind as soon as possible, select the blind's position carefully. Hug the edge of a line of trees or tall grass.

While songbirds and waterfowl aren't as suspicious, they do notice anything new and may take a few hours to accept a blind. If you're working a riverbank or coastal marsh, try setting up where flotsam often washes in at higher water levels. If you stay low to the ground and can find a way to blend in, birds will often accept you as something that floated in with the last tide.

Add a few confidence decoys: perhaps some plastic floating ducks like the hunters do. Easier to use and quite effective can be a plastic replica of a great blue heron. Outside of Florida, these birds often display a wariness matched only by black ducks among the marsh birds. Placing a great blue heron out there makes the other birds think: if it's safe for him, it's safe for me. That the decoy serves as a natural gray card is a bonus for the camera hunter hiding in a blind.

The lower position from sitting makes for a better camera angle. Shoot at or below a subject's eye level for the most pleasing results. With a duck, that's pretty hard to do!

■ REALLY PORTABLE BLINDS

Some folks use the floating inner tube blinds described in the last chapter, camouflaged with natural vegetation such as reeds and cattails, to gain proximity to waterfowl and loons at a lower eye level. I've not felt the need to do that, and must confess a bit of reluctance to risk expensive camera gear over water in what might turn out to be a leaky vessel. As we'll see in the next chapter, you can achieve almost as low a camera angle from a canoe.

TOP—While this photographer blends in the edge habitat, the big white lens gives away his position. BOTTOM—This camouflage works well no matter what color your lens is. This photographer and his equipment blend well.

16. camera platforms

- Can you use a tripod from a canoe?
- What works even better than a window mount when shooting from a car or truck?

The term "camera platforms" comes from the military. The cameras used to acquire aerial photographs require a platform to get them into position, be it a manned surveillance aircraft, unmanned drone, or perhaps a satellite in space.

While wildlife photographers don't have such platforms at their disposal, we do have a number of ways to get into advantageous camera positions that many overlook. We've already seen that a motor vehicle or a watercraft can provide an effective way to really move in for some superb shots. And yet how many folks drive up close to or even right beside an animal and then jump out to take its picture—and scare it off?

While chapter 14 covered some better ways to approach an animal, it didn't tell how to make that motor vehicle or canoe or boat—perhaps even a small aircraft—into a stable camera platform.

■ MOTOR VEHICLES

Let's look at the motor vehicle first. To make it a stable camera platform, many photographers use a window mount. Others just plop a simple beanbag onto the open window frame of the vehicle and rest their lens on that.

Window mounts come in several types. The most secure hang over both sides of the open window and lock into position without touching any glass. Another type attaches to the last several inches of a lowered window. With both types of window mount, the heavy-duty versions provide greater stability.

With any of these devices or the beanbag, you have to shut the engine off to stop vibrations that can affect the sharpness of your images. You and any passengers must also sit still. The whole vehicle in effect provides the platform, and it must be steady.

While each of these camera platforms has its merits, an easier way to gain real stability while shooting from a vehicle exists. And because you make use of your tripod, it saves money, space, and effort in carting around a heavy window mount or beanbag.

Out of necessity—a defective window on a rental car crumbled into my lap in Yellowstone while using a clamp-on window mount—I figured out a way to use a tripod that is as sturdy as any window mount, even the ones that hang over the window. It does require a tripod with legs that spread out at a 90-degree angle to the tripod head. Many tripods,

including most of the popular Gitzo and Bogen models used by nature photographers, do that. Here's how:

- adjust two legs short enough to hit the floor
- make sure that the entire tripod head clears the window frame
- press those two legs against the door, one in front, one behind the seat
- pull the third leg up to a 90-degree angle to the other two
- extend that leg across the vehicle to the passenger side door
- push against the door to make a tight fit and lock the third leg.

With a bit of adjusting, you can set the tripod so that you can drive without any interference, and even have someone sit in the other seat. Just be sure to shut the engine off when you stop to shoot to eliminate vibrations.

If another photographer sits on the passenger side, set the third leg tight to the center "bump" in the car. Its not as steady, but it works if needed.

With two photographers shooting from a vehicle, it's better to both shoot from the same side when possible. That permits the driver to approach any animal so that both have an opportunity to photograph it.

One real advantage to this method of making a vehicle a stable camera platform is that when you fly to a shoot, you only need to bring your tripod. With tighter airline baggage restrictions these days, that's a bonus.

TOP—A tripod set up in a vehicle can make a more secure platform than a window mount. BOTTOM—Sometimes hugging the vehicle works. This Missouri bald eagle felt comfortable with the distance as long as the photographers stayed beside the truck. One used a beanbag; the other a tripod.

■ CANOES

Next, consider the canoe as a camera platform. To get comfortable with that, you must first overcome the phobia that cameras and canoes don't mix. That phobia is deservedly strong. Take it from one who employs special care with the cameras and lenses relied upon for professional wildlife photography: getting used to risking them in a canoe doesn't come easily. But when you realize the images you can make by taking that risk, you figure ways to minimize mishaps and that reduces your "cameracanoeitis."

The partial cure: get in a canoe without your stuff and get the feel for it. Go out with an experienced canoeist or take a course. Then practice on your own.

While a canoe may feel a bit tipsy at first, that may not be a true indication. You should also know that a canoe that seems quite stable initially might be one that tips quite easily when you pass its point of balance, such as by leaning out too far with a heavy telephoto lens! The canoe that feels a bit tipsy may just be the safer one for the camera hunter.

Part of my cure came from spending hours in a canoe with experienced canoeists, including a friend who secures his camera while in a canoe in an airtight plastic kitchen container—once it's empty of his wife's whoopie pies!

Which bring us to the next step in reducing "cameracanoeitis": figure out ways to protect your gear in case of an upset. First, a war story. Tom Chamberlain, formerly managing editor of *Maine Fish and Wildlife* magazine, lost his camera some years ago when his canoe upset in the Allagash Wilderness Waterway. But the camera was wrapped in a plastic trash bag tied at the neck. When he managed to pluck the bag off of the bottom, the thin plastic hadn't punctured, and the knot had held airtight! That bag kept his camera completely dry. He still uses that camera today.

A more reliable method is to get one of the water resistant bags made of thicker plastic that sell for $25 to $50 depending on size. Better yet, purchase one of the watertight hard plastic cases designed to be waterproof at the depths one encounters in most waters worth pursuing wildlife images on. Some camera stores and skin-diving shops carry these cases. But be prepared to spend some real money, in the $100 to $150 range.

I often tie one of those cases to a canoe by a strap through its handle. Is this residual "cameracanoeitis"? Perhaps. But if the worst happens, the case will stay with the canoe. Of course, you do have to take the camera out to take any pictures, so don't rock the canoe!

Sitting cross-legged in the bottom of a canoe once near the shooting area works well to stabilize it and permits using a tripod in a canoe. Keeping the tripod legs short and sitting on the bottom maintains a low center of gravity.

No canoe provides a stationary camera platform if there's any rocking or movement from wind or current. In this case, you usually cannot get sharp images unless you use a fast shutter speed, at least $\frac{1}{250}$ of a second, to minimize such camera motion.

You could handhold a telephoto lens in a canoe if you can get enough light to use a shutter speed that's at least as fast as the lens length, say $\frac{1}{500}$ of a second for a 400mm lens— remember the old rule of thumb?

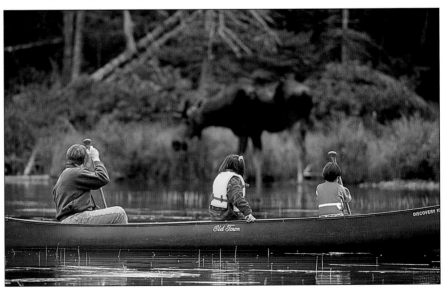

A canoe can make a wonderful way to get closer to wildlife without interfering with it.

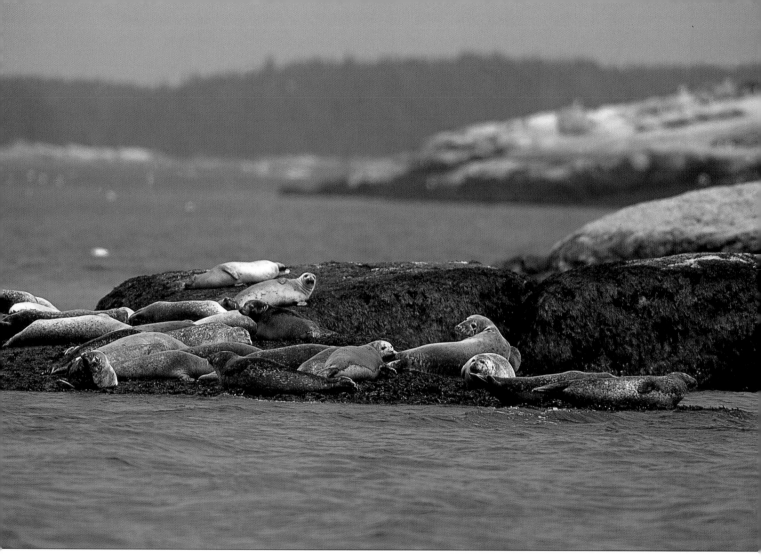

A ninety-foot schooner from the Maine Windjammer fleet served as a great camera platform to get near these wary harbor seals without alarming them.

Better yet, shoot with an IS or a VR lens to handhold in a canoe.

Keep some things in mind about your personal safety when in a canoe. Cold waters can kill. Use a little common sense and wear proper flotation equipment. And don't hang your camera strap around your neck while in a canoe. Would you really want that anchor pulling you down?

■ OTHER WATERCRAFT

Much of the above applies equally to use of a kayak. And as with the floating inner tube blind described in the last chapter, you could get a slightly lower camera angle in one. But since it's tough to set up a tripod in a kayak, The Mooseman prefers a canoe.

Larger, motorized boats often make good camera platforms too. And a sailboat of any size can as well. I've shot on everything from a twelve-foot motorboat to an eighty-foot yacht.

The key to shooting in watercraft lies in controlling camera motion and vibration. Guard against camera motion concerns by using a fast enough shutter speed or an IS or a VR lens. If you control the boat, try to stabilize it by anchoring, or at least sitting stationary while shooting. Be aware that a bit of wave or current motion always exists on most waters.

Also, be wary of vibration concerns if using either a monopod or a tripod. Don't just put an outboard in neutral and expect that to stop its vibrations. Shut the motor off.

On larger boats, if possible have the boat's operator shut off the motor or engine when it's time to shoot if you're using a tripod. An alternative is to fold the tripod legs together and set that "monopod" on vibration absorbing material, perhaps a seat cushion.

■ AIRCRAFT

A small aircraft that you can open the door or window on safely before shooting can make a good camera platform for some special wildlife photography. The best opportunities might seem likely from a helicopter, as the pilot can hold the aircraft stationary over a subject. But since helicopter engines produce lots of vibration, you either need a special gyro-scope, a fast shutter speed, or an IS or VR lens.

Small planes can provide an equally good opportunity with a fast enough shutter speed. A minimum of $\frac{1}{250}$ of a second, preferably at least $\frac{1}{500}$ of a second, is required to get sharp images when you're going 100mph to stay airborne. You also won't want to try using much more than a 300mm lens at that speed—locking on to a target at 6X at 100mph is challenging enough!

As with the need for a blind, the importance of any camera platform increases with the difficulty of the animal that you want to get close enough to for an effective image.

And just what constitutes an effective wildlife photograph? As we'll see in the next chapter, that depends on the purpose of your photograph.

This bird's eye view of a Florida bald eagle's nest shows the habitat it lives in.

17. three types of wildlife photographs

- How do you crop in-camera for wildlife portraits?
- Do editors buy behavior images?
- How do you know what behaviors to photograph?

Wildlife photographs can be classified into three different types:

- wildlife portraits
- behavior images
- scenic wildlife images.

■ WILDLIFE PORTRAITS

Wildlife portraits range from images where the animal's head fills the frame of the photograph to those that show its entire body. Portrait shots include:

- the close-up that shows just the head
- the medium portrait that covers an animal from above its midsection up
- the medium long shot that covers the animal from just above the knee up

A young pronghorn poses for a portrait.

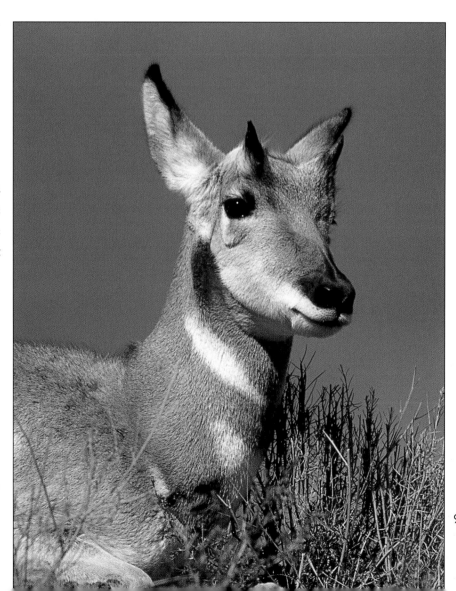

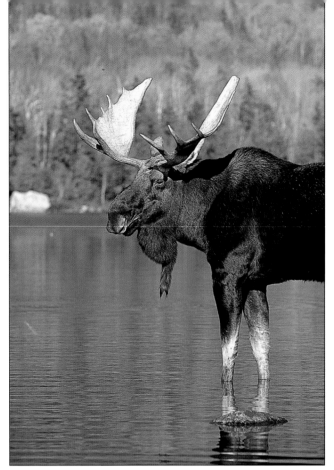 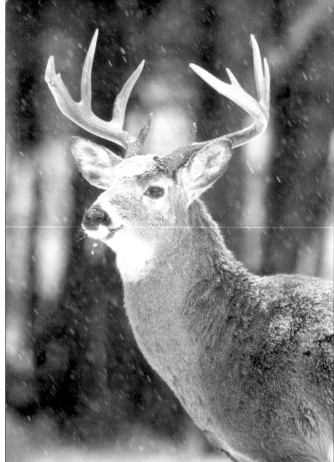

LEFT—I deliberately cropped this moose at his midsection (in-camera) to get his entire rack in a vertical image that showed some of the environment. RIGHT—A more traditional portrait of a white-tailed deer cut him off at the base of the neck.

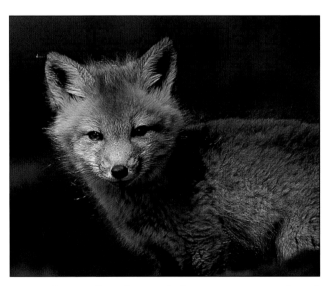

ABOVE—Getting down low made for a more intimate shot of this red fox pup at the den. RIGHT—Shooting at the eye level of this wood stork in a long shot that shows the entire animal gives the image immediacy despite the distance from the bird.

- the long shot that shows the whole figure of the animal.

Cutting an animal off other than at any of these points should be done carefully, as it might look as if the photographer chopped off its feet or other important parts.

The best portraits capture the animal's facial expression and other body language, no matter how much of the subject they include. And as we've seen in chapter 11, you must have at least one of the eyes of the subject sharp.

It's generally preferable to shoot at or below eye level to an animal for more pleasing portraits. While that's easy with a moose, it's a bit difficult with a turtle. But it can be done. Don't be afraid to get down and dirty. If you dress to protect yourself from contact with the ground, you will be more apt to go after lower camera angles. I also sometimes carry a light foam cell sleeping bag pad to kneel or even to lie down and stretch out on if the ground is wet or cold.

Photographers who shoot standing up, with tripod legs extended, not only look more intimidating to a shorter wildlife subject, they also lose immediacy in the portrait's connection to the subject animal due to the perspective.

■ BEHAVIOR IMAGES

The behavior image shows just that: an animal or animals performing some natural behavior. Examples include mating rituals, mothering, fear response, anger response, eating, sleeping—the list goes on and on.

While you might catch the animal in a close-up while doing a behavior, most photographs show some natural habitat around the animal. You'll

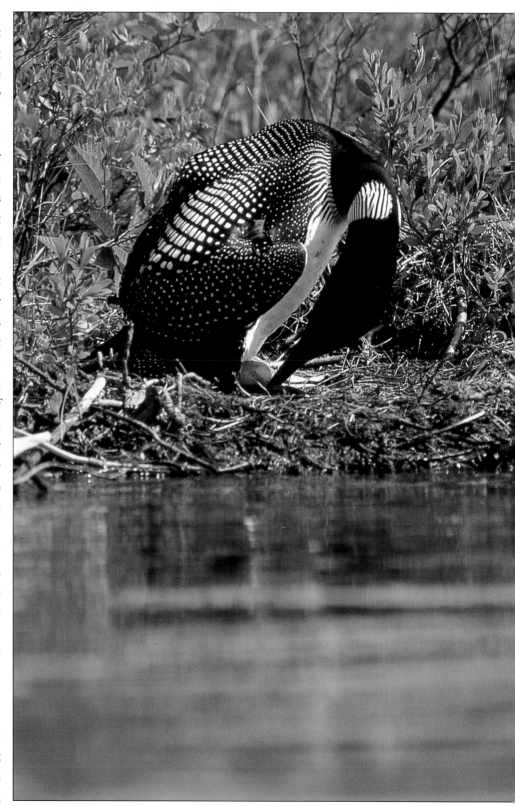

Knowing that loons turn their egg every few hours made me wait for this behavior shot.

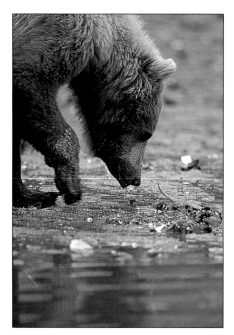

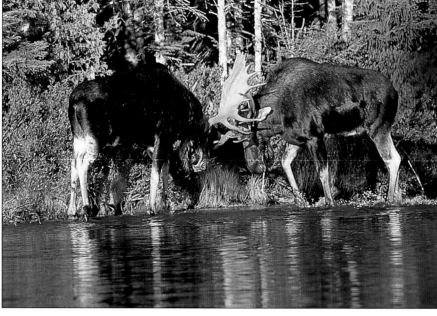

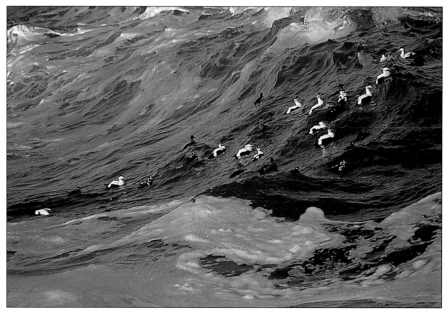

TOP LEFT—Watching for interesting behavior helped to capture a brown bear investigating a crab. TOP RIGHT—Specializing in moose and some other species allows you to target them during the most exciting times of their life cycle. Getting such images takes more than luck—it requires a lot of time on point. RIGHT—This scenic photograph of eider and harlequin ducks riding the surf shows the raw beauty of their natural environment.

usually need some space in a photograph that captures the interaction between two or more animals.

Some photographers miss behavior images because they don't recognize when an animal is displaying a particular behavior. That's because they haven't taken the time to study the species. Once again, the more that you know about any species, the better able you will be to capture its most important behaviors on film.

If you specialize in a species, try to capture its entire life cycle on film. I've done that with moose—that's why they call me The Mooseman. Editors often contact me for moose images, especially behavior shots. Photo editors are always looking for different behavior images.

■ SCENIC WILDLIFE IMAGES
Scenic wildlife images are just that: a scene with an animal in it. Some

photographers also call these shots environmental shots because they show an animal in its natural environment. But the true scenic wildlife image shows more than just the environment of an animal. It also shows a beautiful environment.

It's surprising how many people pass on the opportunity to get these shots. Have you ever watched a photographer "shoot" an animal that's standing in a great scenic location

with only a long telephoto lens—missing the background entirely?

Pay attention to the scene wherever you photograph an animal. And be ready to shoot when an animal gets into the right position in the scene. That's a good reason why you might want to carry two cameras, one equipped with a telephoto lens, the other with a zoom lens or perhaps even a wide angle lens. While it

doesn't happen often, if an animal steps into a stunning landscape in really great light, you want to be ready to bring that picture home. Don't get caught in the trap that you

always have to shoot everything as close as you can.

Most people seem to want to get portraits of wild animals more than any other shots. That's probably

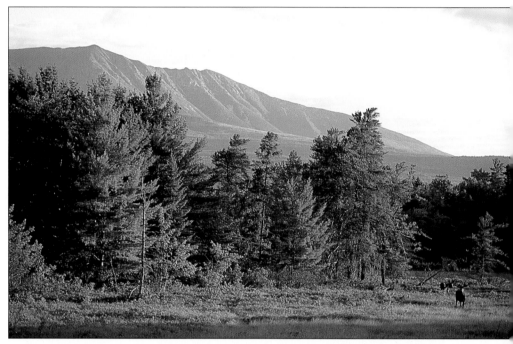

RIGHT—These two moose posing in front of Katahdin made for a scenic wildlife shot. BELOW—Don't fall for the trap that you have to use a telephoto lens on every animal. This moose walked across a fabulous scene in Denali National Park that made a two-page spread in the Moose Watcher's Handbook.

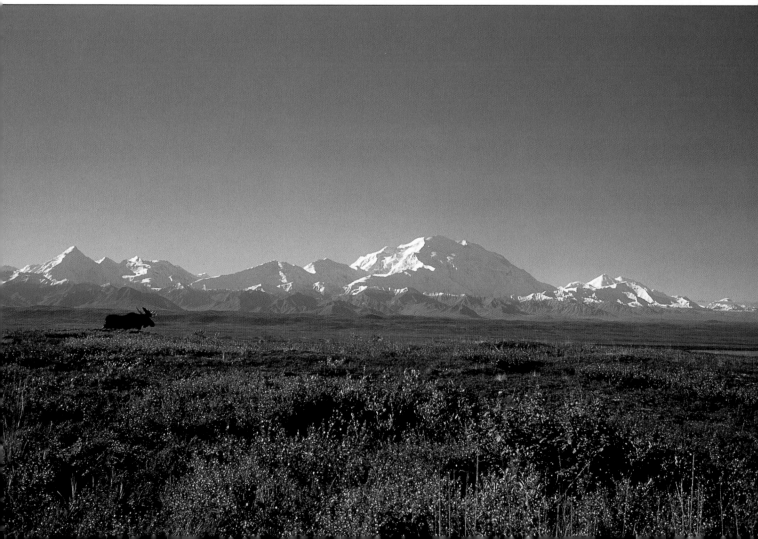

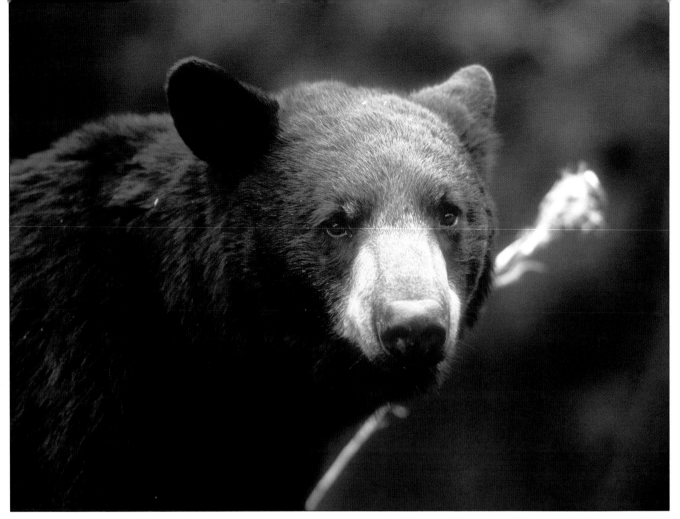

A black bear poses for a portrait.

because magazine covers often feature portrait shots. And yet most photo editors will tell you that they've seen all of the portraits that they ever want to.

That's partly because it's easy to get portraits of animals that you can rent for the purpose. While many published portrait images are of wild animals, a good number are of captive wildlife models. Why? Because it's not all that easy to get close enough to a truly wild animal to fill the frame with its body, let alone its head. For the beginning nature photographer, working with wildlife models offers a way to get experience at following, composing, exposing, and capturing an animal on film.

For the professional photographer, captive models provide the chance to show the beauty of some unique animals so that more people will appreciate them. They also supply images to compete in the marketplace.

But you should understand that some photographers feel that such photographs represent cheating, especially when passed off as photographs of wild animals. The debate involves the role of the photographer as an artist free to make use of all tools available or as a journalist recording nature as it is found. I suspect it also involves pride in one's prowess for the true camera hunter.

As a working professional, I occasionally photograph some captive animals myself, especially rare species or those that are hard to work in the wild. Getting good results still isn't as easy as it might seem. But for The Mooseman, the experience definitely pales when compared to the thrill of successfully capturing a great image of a truly wild animal.

Whether you choose to shoot captives or not, I urge you to follow the Truth in Captioning Guidelines suggested by the North American Nature Photography Association (NANPA), and reprinted here with permission (facing page).

In keeping with that: *all of the photographs in this book are of wild animals, free to go whenever and wherever they pleased.*

Even the portraits? Yes. I just used the techniques described in this book to get them.

North American Nature Photography Association
PRINCIPLES OF ETHICAL FIELD PRACTICES

NANPA believes that following these practices promotes the well-being of the location, subject, and photographer. Every place, plant, and animal, whether above or below water, is unique, and cumulative impacts occur over time. Therefore, one must always exercise good individual judgement. It is NANPA's belief that these principles will encourage all who participate in the enjoyment of nature to do so in a way that best promotes good stewardship of the resource.

ENVIRONMENTAL: KNOWLEDGE OF SUBJECT AND PLACE
- Learn patterns of animal behavior.
- Know when not to interfere with animals' life cycles.
- Respect the routine needs of animals.
- Remember that others will attempt to photograph them too.
- Use appropriate lenses to photograph wild animals.
- If an animal shows stress, move back and use a longer lens.
- Acquaint yourself with the fragility of the ecosystem.
- Stay on trails that are intended to lessen impact.

SOCIAL: KNOWLEDGE OF RULES AND LAWS
- When appropriate, inform managers or other authorities of your presence and purpose.
- Help minimize cumulative impacts and maintain safety.
- Learn the rules and laws of the location.
- If minimum distances exist for approaching wildlife, follow them.
- In the absence of management authority, use good judgement.
- Treat the wildlife, plants and places as if you were their guest.
- Prepare yourself and your equipment for unexpected events.
- Avoid exposing yourself and others to preventable mishaps.

INDIVIDUAL: EXPERTISE AND RESPONSIBILITIES
- Treat others courteously.
- Ask before joining others already shooting in an area.
- Tactfully inform others if you observe them in engaging in inappropriate or harmful behavior.
- Many people unknowingly endanger themselves and animals.
- Report inappropriate behavior to proper authorities.
- Don't argue with those who don't care; report them.
- Be a good role model, both as a photographer and a citizen.
- Educate others by your actions; enhance their understanding

North American Nature Photography Association
TRUTH IN CAPTIONING: A STATEMENT AND SUGGESTED WORDING FOR IMAGES

STATEMENT
As part of its mission, NANPA encourages and helps develop the highest standards of honesty, communication, and comprehensive captioning of nature photography. NANPA believes in photographers' creative freedom to make images as they wish. Yet, it also recognizes that images presented in educational and other documentary contexts are assumed by the public to be straightforward records of what the photographer captured on film. Communicating clearly, efficiently and fully about the making of nature images is thus linked to public trust and acceptance. Creators of images should be truthful in representing their work.

SUGGESTED WORDING
NANPA offers the following categories to assist in maintaining the integrity and trust among nature photographers, photo users and the public. These suggested categories, words and abbreviations are not intended as laws or mandates; they are merely suggestions. Consistent use of them is entirely up to the individual's professional or informed choice. Such choices would include identifying organisms whose status is obvious, such as bacteria and domestic animals. In fulfilling its stated goals, NANPA realizes its responsibility and seeks to provide guidance consistent with truth and integrity for informed individual choice.

WILD—This term, or no wording to indicate otherwise, would identify any creature having the freedom to go anywhere and to disregard artificially set boundaries, with the exception of tracts established to protect the creature for its own sake, and where it lives in a natural state.

CAPTIVE (CAPT)— Applies to any living creature in a zoo, game farm, cage, net, trap, or in drugged or tethered conditions.

PHOTO ILLUSTRATION, PHIL or Actual Situations (DBL. EXP. DIGITAL RETOUCH, COMPOSITE, etc.)— Indicates assembly of an image from two or more images or parts, or removal of significant parts, by computer, darkroom or other means. May include addition or subtraction of elements, duplicating elements within an image, sandwiching different images and removing obstructions. This definition does not include removing scratches or dust, repairing damage to images, or making slight alterations that have traditionally been made by filters or in the printing process.

18. wildlife compositions

- Is it wrong to put the animal in the middle of the frame?
- What are the points of power in a composition?

Artists who draw or paint follow—or at least know when they have chosen to break—the rules of composition. The best photographers do too.

But most wildlife photographers have little classical art training. And

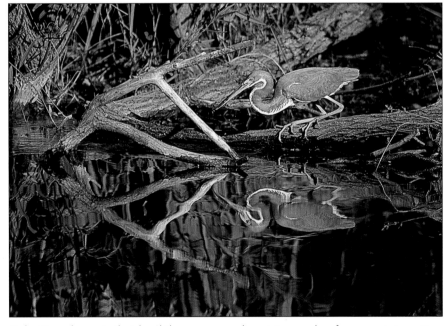

Selecting elements that lead the eye around a picture makes for more interesting photographs. Triangles, diagonal lines, and balance with the subject all work.

so their exposure—pun intended—to the rules of composition comes from looking at their photographs and wondering why they sometimes don't have the impact that the original scene did. Was it the exposure?

The light? The pose? The angle? How about the composition?

While "the eye of the beholder" determines what might be called art, some photographs work better than others. They please us in some way.

Some people have "an eye," and can make such photographs naturally. Since many don't, it helps to find ways to improve on our "vision." To do that, we need to learn what classically trained artists have known for centuries: how the human eye looks at a painting—or a photograph.

■ COMPOSITIONAL ELEMENTS

To attract and hold attention of the eye, a composition should have:

- an entry point
- an exit point
- elements that attract the eye
- balance between the elements.

ABOVE—The out of focus branch distracts from the portrait of this anhinga. RIGHT—The deer's antlers lead the eye up, where the overhanging branches help lead the eye out of the photograph.

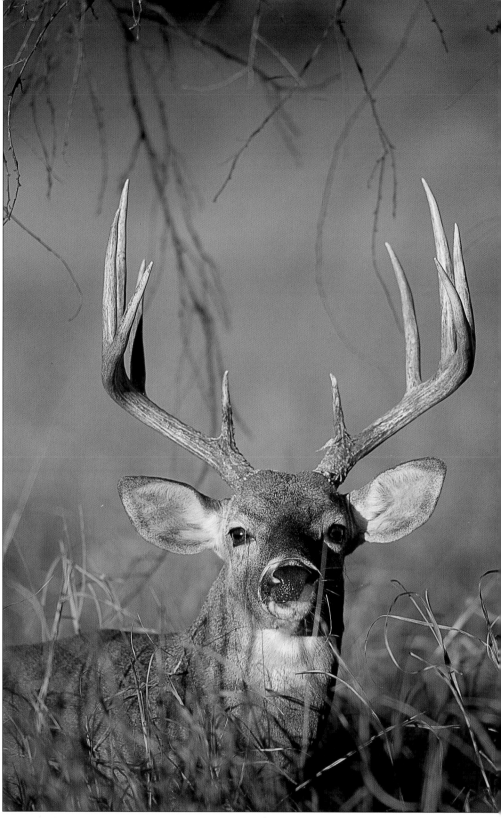

The eye needs a place to enter a photograph that doesn't stop it cold. Sometimes it's the primary subject, sometimes it's something that leads the eye to the primary subject. Painters add other elements besides the primary subject to attract the eye further into a picture. Artistically inclined photographers do too by selecting to include them, as they frame a photograph.

What are those elements? They could be any of many things that add interest to a composition. Some elements found in nature might include: a line made by the horizon or water's edge; a cloud in one corner of the sky; a colorful tree that balances the other side of the frame; or perhaps another animal that draws the eye toward the main subject.

The photographer needs to take care where such elements fall in the composition to avoid drawing the viewer away from the main subject too quickly, or worse, totally. For instance, a significantly brighter object that immediately pulls your eye away from the animal subject might do that.

Compositional lines—perhaps a row of trees, a shoreline, or a rocky hillside in the background—draw the

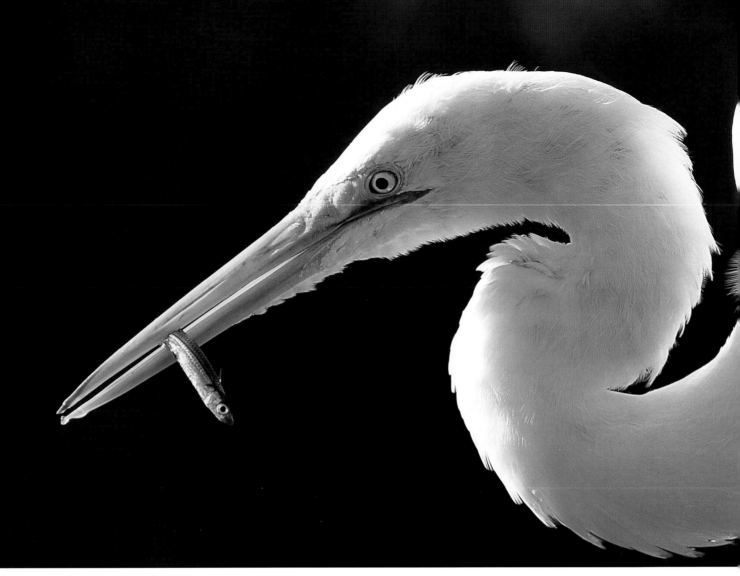

The diagonally held bill of the egret leads our eye out of this picture after exploring the egret's eye and that of the fish.

eye into, across, up, down, and out of a photograph. While all can help the composition, we need to think about how distracting any such lines might be. A background horizon that cuts the subject in half while leading the eye off the photograph may hurt our composition.

We do need to provide the eye a way out of the photograph. If the viewer's eye locks on to a single spot it feels trapped and probably loses interest quickly. We should offer a pathway out of a picture. Perhaps we can use a fainter distant element, converging lines that recede, or simply a perspective that draws the eye into the distance. With a portrait of an animal that fills the frame, it might be a curve on its face or body that points us to the edge and out.

Balance comes from placement of an element in a composition against something of equal attraction to the eye. To better understand how this works, first consider that each element in a picture has a given value, or weight. That weight depends on a number of things, including the following:

- an element near the edge has more weight than one in the center
- an element by itself has more weight than one mixed in a group
- an element in the foreground has less weight than when in the background (assuming it is the same size)
- elements with higher contrast to their surroundings have greater attraction
- colors have more or less weight depending on their hue.

The idea is to keep the viewer's eye involved with a composition by providing an interesting design. That can be done any number of ways, perhaps by offering the eye a circular route, a long graceful curve, or perhaps a back and forth attraction of two or more well balanced elements.

Right now you're probably thinking: all this sounds great. But a major difference exists between painting and photography. The photographer has to make do with what the scene has to offer. And the wildlife photographer has an even more difficult job. We work with wild animals that we have to capture on film, not draw into our compositions. While the landscape photographer can maybe tweak his or her compositions, the

RIGHT—Even though out of focus, the tree balances this silhouette of an Alaskan bull moose. BOTTOM LEFT—The line of cormorants and the turtle have balance. BOTTOM RGHT—Cropping with a telephoto lens provides an even more balanced image, with the repetition of the three similar birds.

wildlife photographer often simply doesn't have the time.

All true.

The secret for the wildlife photographer? Train yourself to "see" better. Learn to evaluate a scene in a hurry. Note as many of the following as you can:

• the effect of the direction of the light

• colors you might be able to use
• textures in the scene that might make the photograph more interesting
• possible natural elements to include
• the animal's direction in the frame
• distractions to exclude.

If a good color background or foreground element is available to

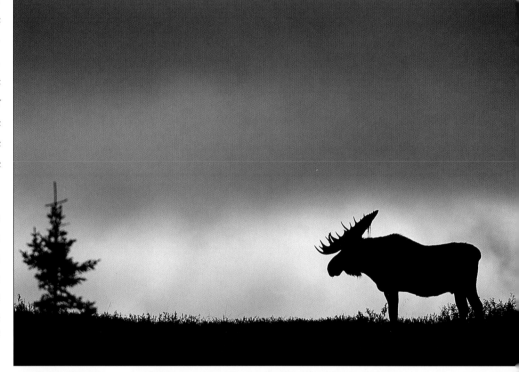

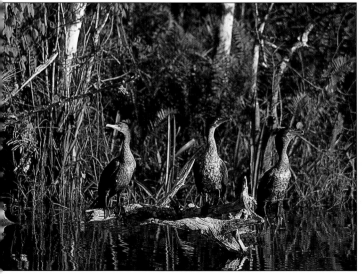

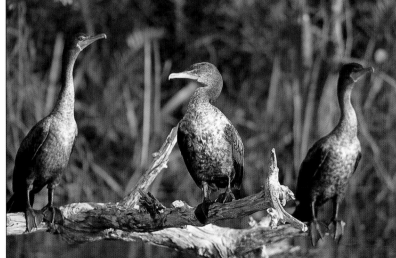

An animal in motion should be entering the frame, not leaving. I panned the camera at a slow shutter speed to show the motion of this whitetail.

include in a photograph, do it. If another animal can be included without distracting from the primary subject, do it. If a pattern in the natural scene that repeats itself or has vivid texture can be included in the composition, do that. Especially if your picture is a scenic wildlife image.

Select your framing so that your primary animal faces into the picture, not out of it—especially if the animal is in motion. An exception to that might be when you're trying to show motion by panning at a slow shutter speed on a moving animal. In that case, you might need more space behind the animal than in front of it to capture the best effect.

Remember that all of these rules are made to be broken. Photographers who only follow the rules of composition blindly fail to see the creative possibilities in other ways to compose an image.

Train yourself to look for those distractions to exclude from your photographs. While the painter adds to a canvas to improve a composition, the photographer usually needs to subtract to make a photograph better. Too much clutter, especially near the main subject, usually hurts a photograph.

■ THE RULE OF THIRDS

One of the easiest composition rules for the wildlife photographer to remember is called the Rule of Thirds. By the Rule of Thirds, we divide a picture into three equal parts horizontally and three equal parts vertically. To easily grasp this, men-

tally draw the game tic-tac-toe. Now think about where you might place an animal in your photograph. The center square? This makes for a rather boring composition, doesn't it? How about the lower left square? That works, if it's not too close to the edge of the frame or looking to the left.

Now think about placing the deer where the left-most vertical line and lowest horizontal line intersect. That's better, isn't it? The intersections of the dividing lines are considered points of power. An element placed at one of these points has more eye attraction.

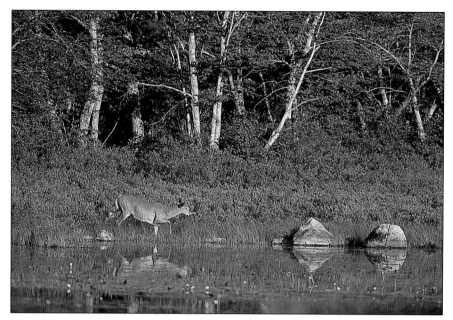

■ HORIZONTAL OR VERTICAL?

Many photographers overlook the chance to make vertical photographs. Perhaps that's because we see the world horizontally. Train yourself to think about flipping the camera into a vertical position.

How do you know when to shot a vertical? While that might be in the eye of the beholder, with some subjects it's easy to decide. If shooting a horizontal would include distracting elements on either side of an animal that you can't get close enough to crop out, shoot a vertical. If shooting a vertical would cut off an important part of the subject such that it diminishes a photograph,

TOP—Placing a subject at a point of power can make an interesting composition. BOTTOM—Don't overlook verticals. You can apply the rule of thirds to them as well.

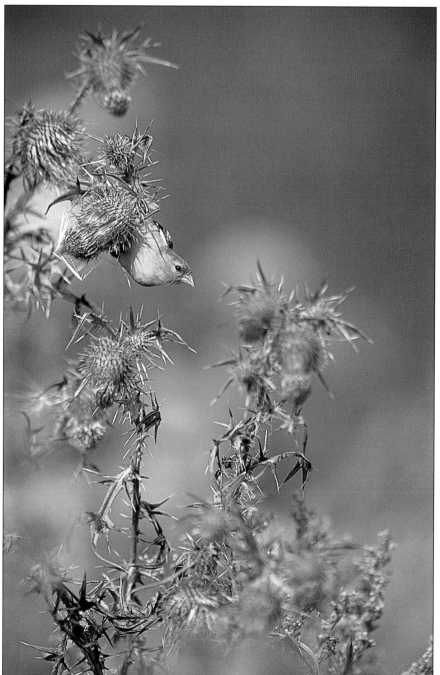

105

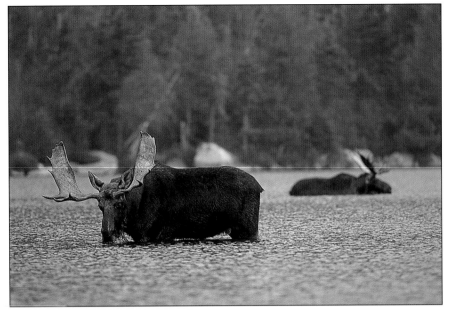

TOP—A horizontal image that has room for the "gutter," where the pages of a magazine are bound, could make a double-page spread. BOTTOM—Pictures that tell a story always make interesting compositions. This tern chick is waiting for one of its parents to bring back food, while its sibling remains unhatched.

shoot a horizontal. If you want to sell photographs for magazine covers—shoot some verticals. Covers pay well. So do two-page spreads, but those are horizontals.

A few last thoughts on composition. Forget all the stuff about where the subject appears and what else is in the frame for a moment, and keep your eye on the target. Think about what you're really trying to do: capture the real essence of a wild animal on film. How can you best do that? Shoot pictures that tell a story. Make an effort to shoot every wildlife image so that it offers a story to the viewer and their eye won't get bored.

Look at some photographs that you like, and see if you can figure out if the photographer used any of these concepts to help do that. Better yet, look at your own photographs and see if you have. Sometimes we do it without knowing.

In the next chapter, we'll explore some of the ways that we can add or subtract elements in the field to improve our compositions.

19. *it's all in your background*

• Do wildlife photographers have any choice of backgrounds?
• How do you get an animal to pose in the right place?

The master wildlife photographer doesn't *take* photographs—he or she *makes* them. We've seen that this involves deliberately composing an image.

We've also seen that an important element in composition is the background. A better background always makes a wildlife image more artful. And so master wildlife photographers find ways to improve on the background. But how can you do that? Don't you have to take what you can get when an animal shows itself? While you often do, if you pay attention to the background, you can almost always find a way to improve on it.

Before we explore some ways to improve on the background, let's first look at a few of the things that you might want to avoid in it to begin with. To improve on any background effectively requires that you first pay careful attention to the scene behind your subject. Is there:

• a distracting bright patch that you should eliminate?
• a background color or similar light reflectiveness that absorbs the subject?
• a horizon or a water line that "cuts" the animal in the wrong place?

Any one of these can spoil a photograph. The problem is that you might not see that as you work with an animal.

The trick again is to train yourself to look. Learn to see what's out there so that you can figure out ways to avoid the things that negatively impact your photographs. Then learn how to apply one of the ways to improve on the background, and you'll make much better photos.

As difficult as this might sound, it's really not all that hard. And it is one of the key things that separate the master shooters from the picture takers.

Some ways to improve on the background include:

• select a stunning background and wait for an animal to show up
• raise or lower the camera angle to eliminate distractions
• move the camera position to put the animal in front of a better background
• wait for the animal to get in front of a better background
• direct the animal toward a better background.

■ SELECT THE BACKGROUND

You can try setting up at a great scenic spot and wait for wildlife to step into the picture during those

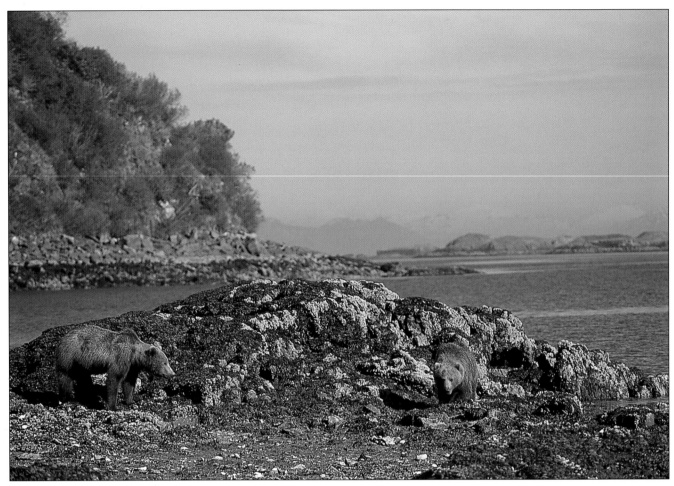

fleeting moments of golden light. Professional wildlife photographers sometimes do this. It doesn't happen often, so if you do this, be ready. Have the light metered and your camera set up with the lens that you need for the target that you anticipate. And don't spare the film if one shows up!

■ RAISE OR LOWER THE CAMERA

Raising or lowering the camera often presents the easiest way to make a better photograph of any wildlife subject at any location. Sometimes, you can get a clean, neutral-colored background that makes your subject pop out of the picture, especially with the limited depth of field of a telephoto lens. You can also often

ABOVE—Not a bad scene for two brown bears to step into. FACING PAGE—Lowering the camera offered the chance to balance the out-of-focus vegetation with its reflection and to add more interest to this composition.

eliminate any distracting natural elements this way.

■ MOVE THE CAMERA POSITION

Moving the camera position parallel to the animal provides an even greater opportunity for removing distractions and selecting natural elements for the background that will improve your photograph. While you can't always do this, either because of the terrain or because you'll scare the animal if you move too much, it doesn't take much adjustment of the camera position to make a significant difference.

■ WAIT FOR THE ANIMAL TO MOVE

If you can't move, sometimes waiting for the animal to move into a better scene works. Your knowledge of the species might guide whether you want to try that or not. How well can you predict what an animal is going to do next? The more you know of the characteristic behavior of its species, the better chance you'll have in doing it.

■ DIRECT THE ANIMAL

The better option might be to direct or attract the animal to the scene you'd like to photograph it in. And

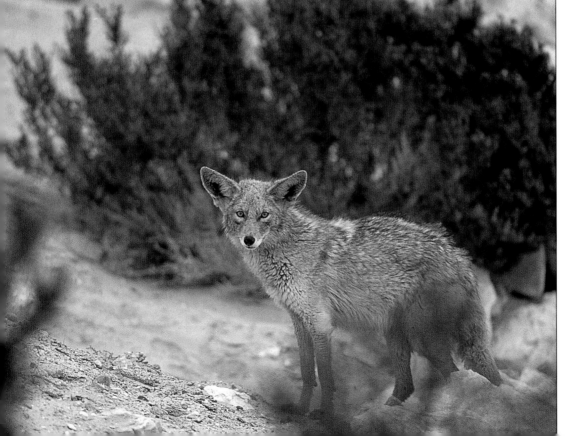

ABOVE—Knowing that the bald eagle might well perch on the muskrat house for a long time, I waited for hours for a "window" of flying snow geese to open in the right place. LEFT—This coyote in Baja California Sud came in to the call of a wounded rabbit.

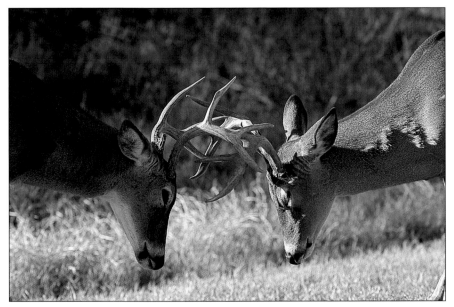 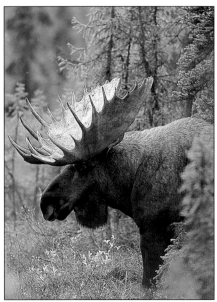

LEFT—Rattling a pair of deer antlers often brings in a curious buck to investigate the sound. In this case, real deer did the rattling. RIGHT—The camera hunter's "trophy" lives to see another day.

just exactly how does a photographer do that with a wild animal? Where permitted, you can direct where an animal will pose by attracting it to a specific spot with food. Place the food so that it doesn't show in your photographs. Consider the direction of the light for the time of day when you plan to photograph as well as the background.

Depending on the species, you can also sometimes direct a wild animal by "calling" it. Wild animals will respond to the sound of their offspring, a mating call, or a "predator call." The call of a young animal makes a powerful draw for a mother of the species. A mating call can have as strong a draw during the right season. The predator call simulates a wounded animal of a prey species—say a snowshoe hare—and draws the attention of a predator species.

If you work at it, you can learn to simulate some wildlife calls simply with your hands and mouth. Hunt-ing supply stores also sell a variety of mouth call devices, tape recordings for game-calling machines, and mechanical calls.

An animal call should only be used with utmost care, as you are interfering with the life of the subject any time you try to attract it by calling. The difference between a little misdirection and outright harassment may be only a matter of degree. Consider how much distraction you might cause an animal and what consequences you might expose it to by calling. Also consider how often others might be calling in the same area that could cumulatively impact an animal. And don't call too often in the same area yourself.

If you plan to try calling any animal, always ask yourself first: is it worth it to risk the animal to get a picture? If it is a critical time of year, where any wasted energy in responding to a faked call might jeopardize the welfare of the animal or its off-spring, don't do it. That will require educated judgment on your part. If you haven't done your homework and you don't know enough about the species, don't try to call it.

Some condemn any deliberate changing of the attitude of a wild animal to photograph it a violation of nature ethics. While I understand those concerns, as long as it remains legal for trophy hunters to call in majestic moose or elk or white-tailed deer to shoot them with a weapon, I reserve the right to call one in where it's legal to do so if it does not cause undue stress. The camera hunter brings them back alive.

20. *lighting: au naturel?*

• Is front lighting better than side lighting for wildlife images?
• How do you take good photographs on cloudy days?

Some folks think that a blue sky with bright midday sun is what wildlife photographers want for their pictures. Wrong. The top lighting of a high overhead sun casts harsh shadows and creates "hard" light that usually makes unattractive images.

Light from the lower sun angles of early morning and late afternoon filters through particulates in the air close to the earth's surface and is "warmed" in the process. Nature photographers call the resultant character of such light a variety of things: artist's light, golden light, or sweet light. I think of it as truly great light.

On any given clear day there's a chance for such light from sunrise into the early morning and again from late afternoon until sunset. The first and last hours of the day often provide the most dramatic light.

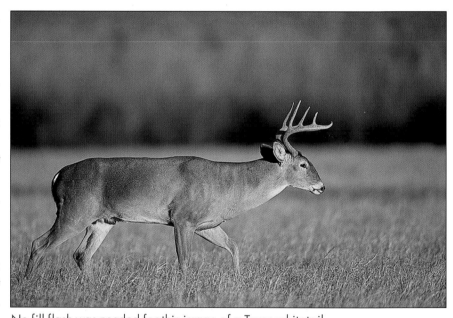

No fill flash was needed for this image of a Texas whitetail.

Professional wildlife photographers consider these the best hours to take to the field, as they not only offer the best light of the day for photography, they also coincide with a prime chance to see animals. That combination of great light and a higher likelihood of wildlife sightings turns the first and last hours of the day into the magic hours.

Most wildlife photographers make their outdoor images using only natural light. While that restricts one's possibilities for bringing back pic-

tures, to capture a wild animal in truly great light transcends wildlife photography far beyond the mere recording of light on film. No artificial light can match that for The Mooseman.

If it really matters, you could use a flash, either as the main light source—less preferable for natural looking photographs—or as a fill light. If you're interested in using flash, see the discussion in chapter 11.

The latitude of your location and the time of year both make a significant difference on how long truly great light lasts on any given day. That's again because of the sun's angle. Winter in the northern latitudes of the lower forty-eight United States actually makes for pretty nice light most of the day. By March, the sun gets higher in the sky before noon and becomes hard light again on a blue-sky day.

Weather conditions obviously affect the quality of natural light as well. You can sometimes still see great light much later in the morning or earlier in the afternoon. Many days offer sweet light most of the day because of cloud conditions.

Surprisingly enough, once the sun's higher in the sky, light overcast days actually provide the best lighting conditions for some wildlife subjects. Consider the bull moose during the rut. Because their racks are so white and brightly reflective as compared to their dark coats, if you shoot one under bright overhead light, you'll probably blow out his rack and throw out the photos.

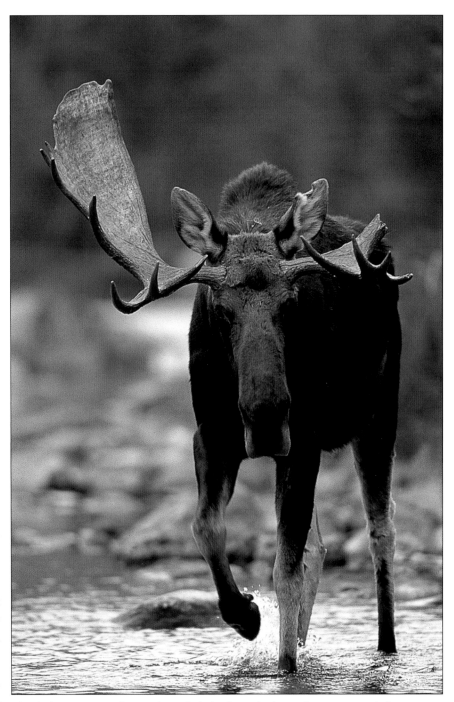

The light overcast sky made soft light for a balanced exposure of this moose image—a picture that tells a story.

Light overcast days offer generally good light for wildlife photography. The hard light source of the sun softens as it spreads throughout the sky. Shadows likewise soften. While texture suffers, film can capture subjects evenly and with fine detail on soft light days. The large light source emphasizes form.

Heavily overcast days generally make for poor quality wildlife photography. Light is often so low that you get neither a decent shutter speed nor any depth of field. And

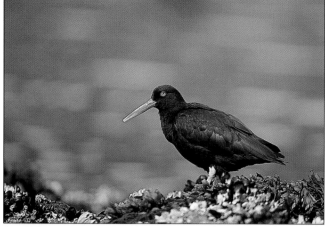

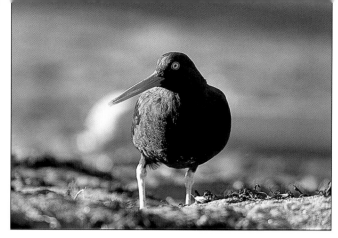

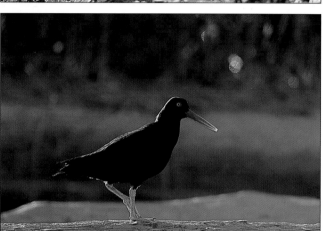

TOP LEFT—Front light on this oystercatcher lights the bird evenly. The different background and short depth of field make the bird stand out, something that can be a problem with some front lighting situations. ABOVE—While strong side lighting on the bird makes for a more dramatic image, but one half of its body is lost in shadow. LEFT—While backlighting is more difficult to meter and causes a loss of detail in the subject, the flared rim light makes this the most dramatic image of the three.

colors can look dull under too heavily overcast conditions.

But even an extremely cloudy day might present a chance for a truly great light moment if the sun squeezes through an opening and spotlights an animal. Find a target lit by one of those beams of light, and you can make some great pictures.

In addition to the effects of the warmth of different natural lighting, the wildlife photographer should also learn to consider how its direction impacts the way a subject looks. Basic directions for natural light useful for wildlife photography include:

- front lighting
- side lighting
- back lighting
- light reflected from below.

■ FRONT LIGHTING

Front lighting comes from behind the photographer to light up the front of the subject evenly and without any shadows, and so little texture shows in the subject. Since contrast is reduced, many people think they should put the sun at their back for the best light. Colors will record well, but front lighting often makes for flat looking photographs. While it might also depend on how the subject stands out compared to the background, there will be little depth to your photographs.

■ SIDE LIGHTING

Side lighting accentuates the texture of a subject. It also gives photographs a three-dimensional aspect, because each raised surface of a subject casts a shadow, creating a feeling of depth in the picture.

Low sun angle side lighting offers great lighting for portraits of animals, as the balance between soft sweet light and the modeling provided by its direction show both detail and depth. But too bright and hard a side lighting casts such dark shadows that it might be a problem. If you can, try to alter the angle of the light by moving so that quarter lighting illuminates your subject.

■ BACK LIGHTING

Back lighting offers the photographer who dares to use it the chance to make some dramatic images. Many avoid it because of metering difficulties. Experiment with a variety of ways to capture a backlit subject. One effective way is the silhouette, where you meter the light source to set an exposure. The animal fades all to black. Spot meter the light itself in

an average area to set an exposure for a silhouette.

If you want to show any detail or color in a backlit subject, spot meter the side of the animal that's facing you and try that. The flare of light coming around the animal often resembles the accent or rim lighting that studio portrait and especially glamour photographers use to add excitement to an image.

■ LIGHT REFLECTED FROM BELOW

Light reflected from below also can give the wildlife photographer who pays attention the chance to make some unique images. The light off of snow or the surface of a pond combined with one of the other types of natural lighting can serve as a reflector in the face of an animal.

The trick in making the most of any natural lighting situation is to see the light to begin with. Train yourself to recognize the different types of light nature offers and to notice when it changes. And when you see *truly great light,* grab a camera!

And remember what we saw in chapter 5: the photographer also has to consider how his or her film handles any type of light. Dark portions of a composition fade to black, overly bright highlights wash out, and shadows sometimes obscure important features of an animal; all impact the photograph.

For example, a bull moose in the fall requires an exposure that pro-

vides for detail in his dark face without blowing out his much more reflective, lighter hardened bone antlers. Moose racks darkened by rubbing against trees are somewhat easier, but they still often reflect lots of light. If you shoot a bull moose in the fall in early morning or late afternoon light, you're all set. Otherwise,

it's best to catch the animal in the shade or on a light overcast day for best results.

Pursue your wildlife photography with knowledge of the many ways that light affects your efforts, and your photographs will improve considerably.

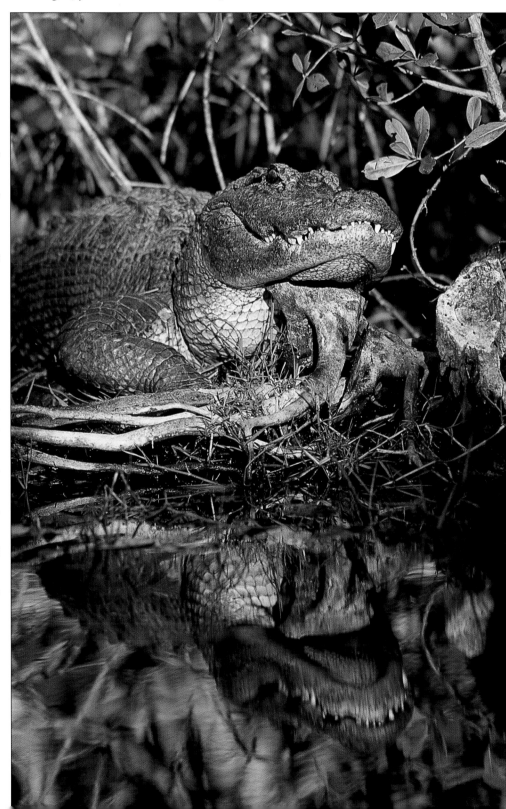

The light reflecting off the water helps to light up this alligator's chin, which reflects back down onto the water.

21. what's wrong with this picture?

- Can you use a slide projector to edit your work?
- Does a computer monitor make a good tool for editing digital images?

The Mooseman's seventh rule of wildlife photography says that the very best way to improve your photography is to critically review all of your results.

Professional photographers do it for every roll of film. They know that there are lessons to be learned from their mistakes as well as from their successes. They know that if they take the time to figure out what went wrong as well as what went right, the next time they go after similar images the knowledge gained will improve their odds of bringing back good images. They edit with care as they check for:

- proper exposure
- critical focus on the subject
- sharpness of the overall image
- color rendition
- effectiveness of the composition
- the best pose

- images with distracting elements—and more.

While the serious wildlife photographer should pay attention to all of the above, different recording media present different concerns as to how to do that.

■ EVALUATING CHROMES

Slide shooters should have at least a 4X loupe magnifier (preferably an 8X loupe) to view their work. Viewing a slide through a projector can never tell you if an image is critically sharp.

For accurately judging color and exposurey, slide shooters should preferably have a professional light table. You can use the less expensive versions, typically powered by an incandescent bulb; alternately, you can hold a slide up to the sky and look at it through a loupe. However, neither of those methods meets the

standard by which the most serious photographers and photo editors will judge chromes. Professional light tables illuminate a slide with light at the color temperature of 5000 degrees Kelvin. The Kelvin scale measures the "coolness" of light based on its color temperature. The lower the number, the warmer the-light. An average blue sky falls in the 6300 degrees Kelvin temperature range, while the incandescent bulb is around 3000 degrees Kelvin. See the problem?

■ EVALUATING DIGITAL IMAGES

Digital shooters face a bigger problem. The color temperature of the average out-of-the-box monitor could be as high as 9300 degrees Kelvin! To accurately judge the color and exposure of a digitally acquired image—not to mention any digital images that you scan from film—you

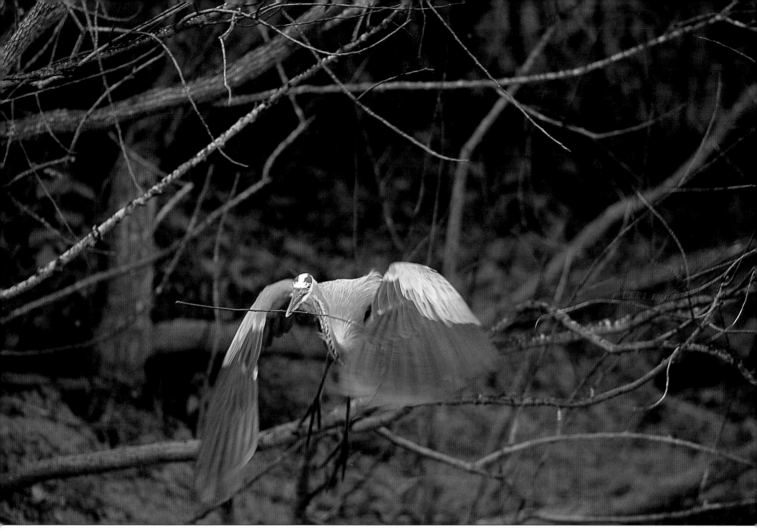

You need an 8X loupe to judge the critical sharpness of the eye of this great blue heron in the original slide.

must calibrate your monitor. I use the OptiCal made by Color Vision and calibrate my monitor weekly or before evaluating any critical work.

Digital shooters should also learn to read the histogram of the digital file as an aid to evaluating their work. And they probably should blow up their image to 200 percent to look for artifacts and to better evaluate sharpness and pixelation.

Digital photography is a subject worthy of several books by itself. *Beginner's Guide to Adobe® Photoshop®, 2nd. Ed.* (Michelle Perkins; Amherst Media, 2003) is a good place to start understanding how to best use this newer way to photograph wildlife.

■ EVALUATING PRINTS
Print shooters should be careful who does their color printing to best evaluate their work. One-hour labs just might not have the freshest chemicals or use the greatest care to make prints. While most do pretty good work for average images, anything hard to print by machine will often lose a lot in the transition from the original negative.

You can train yourself to evaluate the density of your negatives to judge exposure concerns. But it's usually impossible to know for sure about the colors in negative film.

That's another reason why most publishers still want chromes today.

The color print film shooter would do well to get and learn to use a good film scanner. The better models handle color negative film quite well.

Once you've got a digital file you can then control the color management—if you know what you're doing. Many of the same concerns that face the digital shooter will then apply to you as well.

You can make very nice prints with your computer and even an inexpensive inkjet printer. The better the paper and ink used, not to mention the cost of the printer, the longer those prints will last without fading. Isn't technology fun?

22. *be prepared—always*

- What lens should you have on your camera when you walk into the woods?
- How do you keep your camera batteries from failing just when you need them most?

The Mooseman's eighth rule of wildlife photography says that those with their cameras ready to shoot get the most keepers.

Being prepared for wildlife photography includes everything we've covered in this book so far and more—a whole lot more. As you head into the woods or the wilds, whether on foot, in a vehicle, or paddling a canoe, ask yourself:

- Is your camera loaded with enough film? Or is it on frame thirty-four?
- Do you have an extra set of batteries?
- Is the power turned on?
- What's it set for? The $^1/_2$ second f16 from when you were playing with slow motion waterfalls last time out?

In essence, are you ready to shoot if an animal jumps out in front of you? That kind of dumb luck only favors those who are prepared. But it's not dumb luck, is it? You planned to be there at that time for the species that you expect to find to photograph. So doesn't it only make sense to be ready to shoot—always?

■ READY OR NOT

The Mooseman always carries two camera bodies loaded with fresh film, turned on and metered for the existing light when entering the wilds. One has a 500mm lens hooked up to it; the other typically has the 80–400mm zoom VR lens. On long hikes or in inclement weather, the big rig stays snug in a camera backpack that makes for much easier carrying while zipping open in a wink of a moose's eye. The other camera

hangs on a strap over the shoulder. The tripod hangs over the other shoulder on a shotgun strap that releases from its gathered legs in a heartbeat for quick setup if on foot. Sometimes it lies on the shoulder with the big lens and camera mounted on it, really ready to shoot.

In the truck the tripod lies with legs extended ready to lock and load—unless it's set up with the lens out the window as described in chapter 16.

Extra rolls of film fill one of the pockets of a camera vest that also carries a 1.4X teleconverter, a fully charged nickel metal hydride battery that fits either camera, a lens cleaning cloth, either a short zoom or a fixed focal length wide angle lens for those scenic wildlife shots, a couple large plastic trash bags to protect equipment in a pinch if it starts to rain,

and a plastic sandwich bag to drop exposed rolls of film in. That vest also always has a gray card and a compass in it.

On occasion, the stuff in the vest includes polarizer filters for the extremely rare times when there's enough light to drop one in the 500mm lens or screw it on the front of a smaller one. Polarizers eat a stop or more of light and only really work when the subject-camera axis forms a right angle, or close to it. They're most useful for wildlife scenics with a wide angle lens.

■ WEATHER OR NOT

Neither rain nor snow nor sleet, etc., stops The Mooseman from his date with an animal if it makes sense to stick it out. The large trash bag rips easily to poke the 500mm lens hood through while keeping the whole rig dry when secured around the lens and camera. You can lift the open end and stick your face up to the camera and shoot or change film.

In winter, the worst problem is not not actually keeping your camera warm but keeping your batteries working. The best way to do that is to use the rechargeable nickel metal hydride (NiMH) or nickel metal cadmium (NiCads) batteries that are designed by the camera manufacturer of your chosen equipment. Many models of modern cameras have rechargeable batteries available that

Having the camera ready ALWAYS lets you grab moments like this, when this whitetail stepped into dramatic side lighting.

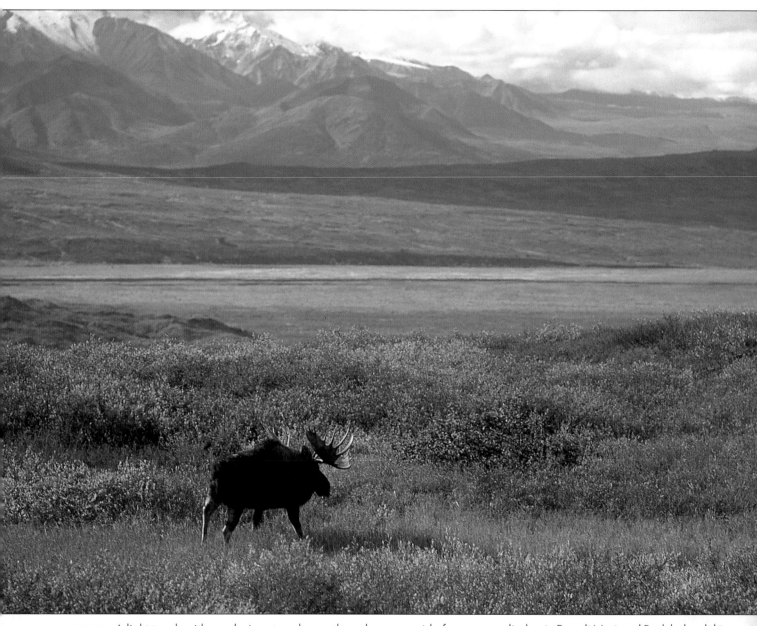

ABOVE—A light touch with a polarizer to enhance the colors on a mid afternoon sunlit day in Denali National Park helped this wide angle shot of a moose in its natural habitat. FACING PAGE—Catch yours in the good light.

work for a long time, even in subzero temperatures.

You can get generic batteries that perform well in the cold. Rechargeable NiCad battery sizes are available that will fit many camera models. Rechargeable AA size NiCads are available at most electronics or hardware stores. Be sure to check your camera manual first about the use of such generic rechargeables, as voltage differences might make a difference in proper operation. Lithium batteries perform better than alkaline batteries in lower temperatures but are not rechargeable.

No matter the battery type you use, keep a spare set warm and you should be able to shoot when you want to. When it's really cold—well below zero—I take the batteries out of my camera and keep them warm in a pocket until needed for shooting. That method was first developed out of necessity while on a seven-mile hike in 20 below zero weather in Baxter State Park in Maine.

Be sure to wipe off any perspiration moisture from stored batteries before you put them in your camera if you're moving about on foot, snowshoes, or skis. And never put your camera under your coat to keep

it warm when you're moving and sweating, as the moisture will freeze on it as soon as the camera hits the cold air. If you keep your batteries warm, a cold camera should do just fine.

You should always bring your camera up to temperature gradually when you come in from the cold. If you're getting in a car, at the very least put your camera gear in the backseat, and cover it with something to protect it from the heater. I put my cameras inside the camera backpack and zip it up so that they are not exposed to condensation as they warm up gradually. A tightly sealed plastic trash bag works just as well, by collecting condensation on the outside of the bag.

And how do you keep warm and dry? My friends from L.L. Bean have a saying: "There's no such thing as bad weather, only bad clothing."

Think about that as you head out to camera hunt. And catch yours in the good light.

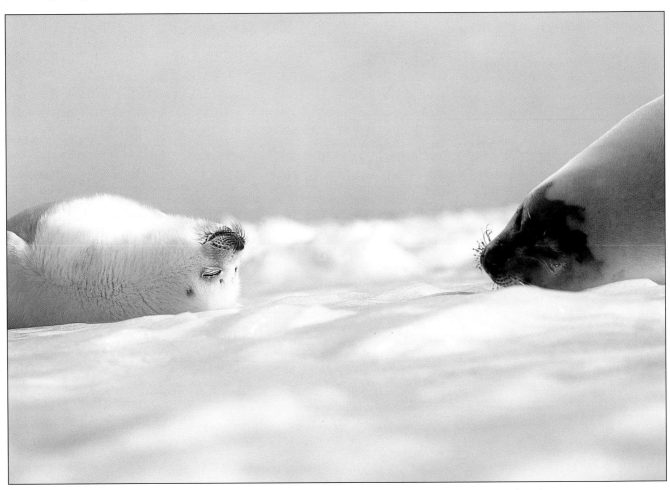

ABOVE—Batteries that keep working in the cold allowed me to work with this sleeping harp seal family.

index

A
Aircraft, 92
Aperture, 66–70
Approach techniques, 76–83
 ambushing, 83
 animal impersonation, 81–82
 camouflage, 77
 fight or flight distance, 82
 mobile blind approach, 80–81
 noise, 77
 open approach, 78–80
 stealth hunting, 77–78
 still hunting, 76–77
Attracting animals, 75, 108–11

B
Behavior images, 95–96
Blats, 18
Bleats, 18, 75
Blinds, 84–87
 mobile, 80–81, 87
 portable, 85–87
 semipermanent, 85

C
Cable release, 32, 55
Calls, 75, 108–111
Camera
 35mm format, 11, 25–26
 cold weather and, 119–22
 digital, 26
 height, 108

(*Camera, cont'd*)
 medium format, 25–26
 mirror lockup, 32
 position, 108
 self-timer, 32
 shake, 32
 shutters, electronic, 32
Camera hunting, 9, 76–83, 108–11
Camouflage, 77
Canoes, 90–91
Captive vs. wild animals, 10
CDs, 38
Composition, 100–111
 backgrounds in, 107–11
 balance, 102
 elements of, 100–104
 horizon lines, 102
 horizontal vs. vertical, 105–6
 rule of thirds, 104–5
 visual weight, 102
Counting, birds, 10

D
Danger, 21–24
Depth of field, 66–70
 around focal point, 67
 tables, 69
 with wide angle vs. telephoto
 lenses, 69–70
Digital imaging, 26, 38–39
 publishing images, 39
 storage devices, 38

Discomfort, 21–24
Dugmore, Arthur Radclyffe, 9–10
DVDs, 38

E
Equipment
 familiarity with, 32–33
 needed, 25–33
Ethics, 98–99
Evaluating images, 39, 116–17
Exposure
 bracketing, 51–52
 compensation for in
 development, 56
 high-contrast scenes, 51–53
 metering, 40–46
 natural gray cards, 47–49
 species adjustments, 50–53
 taking chances, 54–55
Extension tubes, 70
Eyes
 catchlights, 64–65
 color of, 64
 fill flash, 64–65
 importance of, 61–65
 light on, 61–63

F
Film
 chrome, 34, 36
 contrast, 39
 DX codes, 36

(Film, cont'd)
 E6, 36
 exposure latitude, 38
 grain, 37–38
 negative, 34, 36–39
 personal taste, 37
 pulling, 56
 pushing, 56
 selection based on intended
 image usage, 34–38
 speed, 34–36
Filters, 119
Flash, fill, 64–65
Focus
 auto vs. manual, 27–30,
 57–60
 bracketing, 66–70
Food sources, identifying habitats
 by, 73–74
Frame advance, 29–30

G
Grunts, 18, 74

H
Habituation, 20, 83
Hearing abilities, animal, 16–17

I
Inquisitiveness in animals, 17

L
Lens
 autofocus, 27–30
 depth of field, 66–70
 extension tubes, 70
 focusing distance, 70
 mirror telephoto, 29
 quality, 26
 reach, 25–26
 sharpness, 26–27
 speed, 26–28
 teleconverters, 28, 70
 telephoto, 26–28
 weight, 26–27
Lighting, 112–15
 direction, 114–15
 latitude, 113

(Lighting, cont'd)
 on eyes, 62–65
 reflected from below, 115
 time of day, 112–15
 weather, 113
Light table, 39
Loupe, 39

M
Mating season, 74–75
Metering, 40–46
 center-weighted, 44
 evaluating scenes, 41–44
 evaluative, 44
 incident, 44
 gray card, 43–45, 47–49
 manual mode, 41, 45–46
 matrix, 44
 program modes, 40–41
 spot, 44
Mirror slap, 32
Motion, 68–69
Motor drive, 29–30
Motor vehicles, 88–89
 tripods in, 89
 window mount, 88

N
Noise, reducing, 16, 77
North American Nature Photog-
 raphy Association, 98–99

O
Olfactory abilities, 16, 83

P
Patience, 14
Platforms, camera, 88–92
 aircraft, 92
 canoes, 90–91
 motor vehicles, 88–89
Portraits, types of, 93–99
 behavior, 95–96
 scenic, 96–98
 wildlife, 93–95
Predator species, 79
Preparation for the shoot, 14–16,
 22–24, 71–75

(Preparation, cont'd)
 equipment, 118–19
 food sources, identifying habitats
 by, 73–74
 location, 71–73
 mating season, 74–75
 time of year, 71–72
 vest, 118–19
 weather, evaluating, 119–22
Prey species, 78

R
Researching species, 12–20

S
Scanning images, 38–39
Scenic wildlife portraits, 96–98
Scent, keeping from animal, 16, 83
Screams, 18
Shiras, George, 9
Shutter speed, 32
Silhouettes, 62
Snacks, 24
Snorts, 18
Species, knowledge of, 12–20
Stomping, 17–18

T
Tail, position and movement, 17
Teleconverters, 28, 70
Timing, 16, 71–75
Tripod, 30–32
 head, type of, 31–33
 height of, 31
 weight, 31–32

V
Vision, animal, 16

W
Waiting, 14
Watercraft, 90–91
Weather, 22–24, 119–22
Wild vs. captive animals, 10

Z
Zoos, 10

Freelance Photographer's Handbook

Cliff and Nancy Hollenbeck

Whether you want to be a freelance photographer or are looking for tips to improve your current freelance business, this volume is packed with ideas for creating and maintaining a successful freelance business. $29.95 list, 8½x11, 107p, 100 b&w and color photos, index, glossary, order no. 1633.

Infrared Landscape Photography

Todd Damiano

Landscapes shot with infrared can become breathtaking and ghostly images. The author analyzes over fifty of his compelling photographs to teach you the techniques you need to capture landscapes with infrared. $29.95 list, 8½x11, 120p, 60 b&w photos, index, order no. 1636.

Infrared Photography Handbook

Laurie White

Covers black and white infrared photography: focus, lenses, film loading, film speed rating, batch testing, paper stocks, and filters. Black & white photos illustrate how IR film reacts. $29.95 list, 8½x11, 104p, 50 b&w photos, charts & diagrams, order no. 1419.

Creating World-Class Photography

Ernst Wildi

Learn how any photographer can create technically flawless photos. Features techniques for eliminating technical flaws in all types of photos—from portraits to landscapes. Includes the Zone System, digital imaging, and much more. $29.95 list, 8½x11, 128p, 120 color photos, index, order no. 1718.

The Beginner's Guide to Pinhole Photography

Jim Shull

Take pictures with a camera you make from stuff you have around the house. Develop and print the results at home! Pinhole photography is fun, inexpensive, educational and challenging. $17.95 list, 8½x11, 80p, 55 b&w photos, charts & diagrams, order no. 1578.

Handcoloring Photographs Step by Step

Sandra Laird and Carey Chambers

Learn to handcolor photographs step-by-step with the new standard in handcoloring reference books. Covers a variety of coloring media and techniques. $29.95 list, 8½x11, 112p, 100 b&w and color photos, order no. 1543.

McBroom's Camera Bluebook, 6th Ed.

Mike McBroom

Comprehensive and fully illustrated, with price information on: 35mm, digital, APS, underwater, medium & large format cameras, exposure meters, strobes, and accessories. Pricing info based on equipment condition. $29.95 list, 8½x11, 336p, 275 b&w photos, order no. 1553.

The Art of Infrared Photography, 4th Ed.

Joe Paduano

A practical guide to infrared photography. Tells what to expect and how to control results. Includes: anticipating effects, color infrared, digital infrared, using filters, focusing, developing, printing, handcoloring, toning, and more! $29.95 list, 8½x11, 112p, 70 b&w photos, order no. 1052.

Essential Skills for Nature Photography

Cub Kahn

Learn the skills you need to capture landscapes, animals, flowers, and the entire natural world on film. Includes: selecting equipment, choosing locations, evaluating compositions, filters, and much more! $29.95 list, 8½x11, 128p, 60 b&w and color photos, order no. 1652.

Black & White Landscape Photography

John Collett and David Collett

Master the art of black & white landscape photography. Includes: selecting equipment for landscape photography, shooting in the field, using the Zone System, and printing your images for professional results. $29.95 list, 8½x11, 128p, 80 b&w photos, order no. 1654.

Photo Retouching with Adobe® Photoshop® 2nd Ed.

Gwen Lute

Teaches every phase of the process, from scanning to final output. Learn to restore damaged photos, correct imperfections, create realistic composite images, and correct for dazzling color. $29.95 list, 8½x11, 120p, 100 color images, order no. 1660.

Creative Lighting Techniques for Studio Photographers, *2nd Ed.*

Dave Montizambert

Whether you are shooting portraits, cars, tabletop, or any other subject, Dave Montizambert teaches you the skills you need to take complete control of your lighting. $29.95 list, 8½x11, 120p, 80 color photos, order no. 1666.

Black & White Photography for 35mm

Richard Mizdal

A guide to shooting and darkroom techniques! Perfect for beginning or intermediate photographers who want to improve their skills. Features helpful illustrations and exercises to make every concept clear and easy to follow. $29.95 list, 8½x11, 128p, 100 b&w photos, order no. 1670.

Secrets of Successful Aerial Photography

Richard Eller

Learn how to plan a shoot and take images from the air. Discover how to control camera movement, compensate for environmental conditions and compose outstanding aerial images. $29.95 list, 8½x11, 120p, 100 b&w and color photos, order no. 1679.

Professional Secrets of Nature Photography

Judy Holmes

Covers every aspect of making top-quality images, from selecting the right equipment, to choosing the best subjects, to shooting techniques for professional results every time. $29.95 list, 8½x11, 120p, 100 color photos, order no. 1682.

Composition Techniques from a Master Photographer

Ernst Wildi

Composition can make the difference between dull and dazzling. Master photographer Ernst Wildi teaches you his techniques for evaluating subjects and composing powerful images in this beautiful color book. $29.95 list, 8½x11, 128p, 100 color photos, order no. 1685.

Macro & Close-up Photography Handbook

Stan Sholik and Ron Eggers

Learn to get close and capture breathtaking images of small subjects—flowers, stamps, jewelry, insects, etc. Designed with the 35mm shooter in mind, this is a comprehensive manual full of step-by-step techniques. $29.95 list, 8½x11, 120p, 80 b&w and color photos, order no. 1686.

The Art and Science of Butterfly Photography

William Folsom

Learn butterfly behavior (feeding, mating, and migrational patterns), when to photograph, how to lure them, and techniques for capturing breathtaking images of these colorful creatures. $29.95 list, 8½x11, 120p, 100 b&w and color photos, order no. 1680.

The Practical Manual of Captive Animal Photography

Michael Havelin

Learn the environmental advantages of photographing animals in captivity, and how to take natural-looking photos of subjects in zoos, preserves, aquariums, etc. $29.95 list, 8½x11, 120p, 100 b&w photos, order no. 1683.

Dramatic Black & White Photography

SHOOTING AND DARKROOM TECHNIQUES

J. D. Hayward

Create dramatic images with these outstanding techniques for lighting and top-notch, creative darkroom work. This book takes black & white to the next level! $29.95 list, 8½x11, 128p, 80 duotone photos, order no. 1687.

Techniques for Black & White Photography

CREATIVITY AND DESIGN

Roger Fremier

Harness your creativity and improve your photographic design with these techniques and exercises. A complete course for photographers who want to be more creative. $19.95 list, 8½x11, 112p, 50 b&w photos, order no. 1699.

Basic Scanning Guide For Photographers and Other Creative Types

Rob Sheppard

An easy-to-read, hands-on workbook offering a practical knowledge of scanning. Includes selecting and setting up your scanner. $17.95 list, 8½x11, 96p, 80 b&w photos, order no. 1702.

Photographing Creative Landscapes

Michael Orton

Boost your creativity and bring a new level of enthusiasm to your images of the landscape. This step-by-step guide is the key to escaping from your creative rut and beginning to create more expressive images. $29.95 list, 8½x11, 128p, 70 color photos, order no. 1714.

The Art of Photographing Water

Cub Kahn

Learn to capture the interplay of light and water with this beautiful, compelling, and comprehensive book. Packed with practical information you can use right away! $29.95 list, 8½x11, 128p, 70 color photos, order no. 1724.

Advanced Infrared Photography Handbook

Laurie White Hayball

Building on the techniques covered in her *Infrared Photography Handbook*, Laurie White Hayball presents advanced techniques for harnessing the beauty of infrared light on film. $29.95 list, 8½x11, 128p, 100 b&w photos, order no. 1715.

Digital Imaging for the Underwater Photographer

Jack and Sue Drafahl

This book will teach readers how to improve their underwater images with digital imaging techniques. This book covers all the bases—from color balancing your monitor, to scanning, to output and storage. $39.95 list, 6x9, 224p, 80 color photos, order no. 1727.

Zone System

Brian Lav

Learn to create perfectly exposed black & white negatives and top-quality prints. With this step-by-step guide, anyone can learn the Zone System and gain complete control of their black & white images! $29.95 list, 8½x11, 128p, 70 b&w photos, order no. 1720.

Photographer's Filter Handbook

Stan Sholik and Ron Eggers

Take control of your photography with the tips offered in this book! This comprehensive volume teaches readers how to color-balance images, correct contrast problems, create special effects, and more. $29.95 list, 8½x11, 128p, 100 color photos, order no. 1731.

Traditional Photographic Effects with Adobe® Photoshop®, 2nd Ed.

Michelle Perkins and Paul Grant

Use Photoshop to enhance your photos with handcoloring, vignettes, soft focus, and much more. Every technique contains step-by-step instructions for easy learning. $29.95 list, 8½x11, 128p, 150 color images, order no. 1721.

Beginner's Guide to Adobe® Photoshop®, 2nd Ed.

Michelle Perkins

Learn to effectively make your images look their best, create original artwork, or add unique effects to any image. Topics are presented in short, easy-to-digest sections that will boost confidence and ensure outstanding images. $29.95 list, 8½x11, 128p, 300 color images, order no. 1732.

Photographic Lenses

PHOTOGRAPHER'S GUIDE TO CHARAC-TERISTICS, QUALITY, USE AND DESIGN

Ernst Wildi

Gain a complete understanding of the lenses through which all photographs are made—both on film and in digital photography. $29.95 list, 8½x11, 128p, 70 color photos, order no. 1723.

Beginner's Guide to Digital Imaging

Rob Sheppard

Learn how to select and use digital technologies that will lend excitement and provide increased control over your images—whether you prefer digital capture or film photography. $29.95 list, 8½x11, 128p, 80 color photos, order no. 1738.

The Art of Color Infrared Photography

Steven H. Begleiter

Color infrared photography will open the doors to a new and exciting photographic world. This book shows readers how to previsualize the scene and get the results they want. $29.95 list, 8½x11, 128p, 80 color photos, order no. 1728.

Professional Digital Photography

Dave Montizambert

From monitor calibration, to color balancing, to creating advanced artistic effects, this book provides those skilled in basic digital imaging with the techniques they need to take their photography to the next level. $29.95 list, 8½x11, 128p, 120 color photos, order no. 1739.

Toning Techniques for Photographic Prints

Richard Newman

Whether you want to age an image, provide a shock of color, or lend archival stability to your black & white prints, the step-by-step instructions in this book will help you realize your creative vision. $29.95 list, 8½x11, 128p, 150 color and b&w photos, order no. 1742.

The Best of Nature Photography

Jenni Bidner and Meleda Wegner

Ever wondered how legendary nature photographers like Jim Zuckerman and John Sexton create their images? Follow in their footsteps as top photographers capture the beauty and drama of nature on film. $29.95 list, 8½x11, 128p, 150 color photos, order no. 1744.

Beginner's Guide to Nature Photography

Cub Kahn

Whether you prefer a walk through a neighborhood park or a hike through the wilderness, the beauty of nature is ever present. Learn to create images that capture the scene as you remember it with the simple techniques found in this book. $14.95 list, 6x9, 96p, 70 color photos, order no. 1745.

Photo Salvage with Adobe® Photoshop®

Jack and Sue Drafahl

This book teaches you to digitally restore faded images and poor exposures. Also covered are techniques for fixing color balance problems and processing errors, eliminating scratches, and much more. $29.95 list, 8½x11, 128p, 200 color photos, order no. 1751.

Web Site Design for Professional Photographers

Paul Rose and Jean Holland-Rose

Learn to design, maintain, and update your own photography web site. Designed for photographers, this book shows you how to create a site that will attract clients and boost your sales. $29.95 list, 8½x11, 128p, 100 color images, index, order no. 1756.

PROFESSIONAL TECHNIQUES FOR
Pet and Animal Photography

Debrah H. Muska

Adapt your portrait skills to meet the challenges of pet photography, creating images for both owners and breeders. $29.95 list, 8½x11, 128p, 110 color photos, index, order no. 1759.

Heavenly Bodies

THE PHOTOGRAPHER'S GUIDE TO ASTROPHOTOGRAPHY

Bert P. Krages, Esq.

Learn to capture the beauty of the night sky with a 35mm camera. Tracking and telescope techniques are also covered. $29.95 list, 8½x11, 128p, 100 color photos, index, order no. 1769.

The Digital Darkroom Guide with Adobe® Photoshop®

Maurice Hamilton

Bring the skills and control of the photographic darkroom to your desktop with this complete manual. $29.95 list, 8½x11, 128p, 140 color images, index, order no. 1775.

Color Correction and Enhancement with Adobe® Photoshop®

Michelle Perkins

Master precision color correction and artistic color enhancement techniques for scanned and digital photos. $29.95 list, 8½x11, 128p, 300 color images, index, order no. 1776.